# 莫扎特与《欢腾喜悦》

Mozart and *Exsultate Jubilate*

李梦石 著

上海大学出版社

·上海·

图书在版编目(CIP)数据

莫扎特与《欢腾喜悦》/ 李梦石著. -- 上海：上海大学出版社, 2024. 7. -- ISBN 978-7-5671-4985-4
Ⅰ. J624.17
中国国家版本馆 CIP 数据核字第 2024CF8282 号

责任编辑　位雪燕
封面设计　缪炎栩
技术编辑　金　鑫　钱宇坤

**莫扎特与《欢腾喜悦》**
李梦石　著
上海大学出版社出版发行
（上海市上大路 99 号　邮政编码 200444）
（https://www.shupress.cn　发行热线 021-66135112）
出版人　戴骏豪

\*

南京展望文化发展有限公司排版
江苏句容排印厂印刷　　　各地新华书店经销
开本 890mm×1240mm　1/32　印张 5.5　字数 153 千
2024 年 7 月第 1 版　2024 年 7 月第 1 次印刷
ISBN 978-7-5671-4985-4/J·664　定价　68.00 元

版权所有　侵权必究
如发现本书有印装质量问题请与印刷厂质量科联系
联系电话：0511-87871135

# 序　言

在这个科技、音乐和文化交织的时代，我们一方面对人类的智慧和创造力感到赞叹，另一方面对能够体验这种智慧和创造力带来的美好感到幸运。

今天，我向大家推荐一本由李梦石博士独立创作的有关音乐研究领域的著作——《莫扎特与〈欢腾喜悦〉》。李梦石博士是一位多才多艺的艺术家，她不仅精通声乐，还擅长歌剧表演。她的歌声曾感动过无数听众，其中也包括我。作为一名长期从事材料研究的理工学者，我在现场欣赏并被她的演出所折服，她优美的嗓音让我深受感动，这也是我真诚向广大读者推荐这部作品的内在动力。

该著作是梦石博士基于15年的学术研究成果和丰富的表演实践凝结而成的首部文字作品。她以独特的视角和自己的演唱录音，向我们展示了莫扎特《欢腾喜悦》这部音乐作品的魅力所在。正是梦石博士深厚的音乐素养，使她在研究莫扎特音乐时独具独特的视角，意境深远。

莫扎特是欧洲古典音乐的代表人物之一，他的作品具有极高的艺术价值和研究价值。在这本书中，梦石博士详细阐述了莫扎特音乐与歌词的紧密结合。她认为，莫扎特的作曲技巧与歌词表达相辅相成，共同构成了传世之作《欢腾喜悦》。这部音乐作品以拉丁文写成，充满了神秘和庄严的氛围，令人陶醉。

本书还对莫扎特的生平进行了深入剖析，使我们更加了解这位音乐大师的传奇人生。梦石博士以独特的女性视角，揭示了莫扎特在音乐创作中所展现出的柔情与激情。同时，她还探讨了莫扎特音乐对后世的影响以及其在世界音乐史上的地位。

文中分析的四段音乐段落，梦石博士都一一录音并做了自己的诠释，附在书中。作为一部结合了科技、音乐与文化的作品，《莫扎特与〈欢腾喜悦〉》不仅为我们提供了丰富的音乐知识，还让我们感受到艺术的无穷魅力。梦石博士用她深厚的音乐功底和独特的艺术感悟，为我们打开了通往古典音乐的大门。这本书不仅适合音乐爱好者，也适合音乐专业的读者朋友们。

在科技日新月异的今天，我们更需要这样的作品来丰富我们的精神世界。梦石博士的这部作品，正是为我们提供了一个欣赏音乐、了解文化、拓展视野的平台。让我们一同走进这个充满欢腾喜悦的音乐世界，感受莫扎特带给我们的无尽魅力。

上海电机学院党委书记、教授

# Preface

In this era, where technology, music, and culture intertwine, we marvel at the wisdom and creativity of humanity and feel doubly fortunate to have the opportunity to experience the beauty brought about by such wisdom and creativity.

Today, I would like to recommend *Mozart and Exsultate Jubilate*, a book on music research written by Dr. Li Mengshi, an accomplished artist proficient not only in vocal music but also in opera performance. Her singing has moved countless audiences, including myself. As a science and technology scholar who has engaged in material reacher for a long time, I was deeply impressed by her performance at the scene and moved by her beautiful voice, which is also the driving force behind my sincere recommendation of this work to readers.

This book is Dr. Li's first written work based on her 15 years of academic research and rich performance practice. She reveals the charm of Mozart's musical work with her unique perspective and her own singing recordings. Dr. Li's profound musical accomplishment enables her to offer a unique perspective in her research on Mozart's music, which has profound implications.

Mozart is one of the representative figures of European classical music, and his works have high artistic and research value. In this book, Dr. Li provides a detailed explanation of the close connection between Mozart's music and lyrics. She argues that Mozart's

compositional skills and lyrical expression complement each other, resulting in the timeless masterpiece *Exsultate Jubilate*, written in Latin, filled with a mysterious and solemn atmosphere that captivates the reader.

In the book, Dr. Li also delves deeply into Mozart's life, allowing readers to gain a deeper understanding of the legendary life of this musical master. She reveals the tenderness and passion that Mozart displayed in his music creation from a unique female perspective. Additionally, she explores the influence of Mozart's music on future generations and its status in the history of world music.

Dr. Li recorded four musical segments discussed in the book and provided her own interpretations, which are included in the book. As a work that combines technology, music, and culture, *Mozart and Exsultate Jubilate* not only provides readers with rich musical knowledge but also allows them to experience the boundless charm of art. Dr. Li leverages her profound musical foundation and unique artistic insight to open a door to classical music for readers. This book is suitable for music lovers as well as readers in music-related fields.

Today, with the rapid developmet of science and technology, we need such works to enrich our spiritual lives. Dr. Li's work provides us with a platform to appreciate music, understand culture, and broaden our horizons. Let's step into this joyful and delightful world of music together and experience the endless charm of Mozart.

Party Secretary of Shanghai Dianji University, Professor

# 前　言

在西方音乐发展的历史中,莫扎特是一个重要的人物。在其短暂的三十多年的生命中,他以非凡的创作能力撼动了欧洲的音乐界,他的影响力一直延续至今。在他诞辰270周年之际,我以别样的视角走近了这位伟大的音乐家所营造的音乐世界。莫扎特一生创作了交响乐、奏鸣曲、协奏曲、室内乐重奏、歌剧、艺术歌曲、清唱剧等各种不同体裁的音乐。在他众多的作品中,声乐作品以高度契合语言的语汇、精致的旋律和丰富的音乐风格为后世的歌者们所青睐。作品K.165是其1773年所创作的声乐套曲。此时正值莫扎特创作的黄金时期,他以极大的热情创作了这部带有早期音乐风格的声乐作品。

我的契机源于在米兰音乐学院研究生第二年期末考试的时候。当时学校规定每位学生需要演唱一部早期作品。由于莫扎特编号K.165套曲中的一首在中国被编入高等师范院校声乐教材中,在之前的声乐学习中我曾学习并演唱过,于是导师建议我,那就演唱一整部吧。在米兰音乐学院的学习要求中,一般都是唱一整部而没有唱一首的。在这样的情况下,我开始跟随导师进行学习,除了应用于考试之外,在不同的场合还进行了各种艺术实践。

西方早期音乐的发展,成为日后其作曲与作曲理论形成的重要积累阶段。这个时代的音乐充满着各种音乐元素的交织,甚至连我们现在喜闻乐见的种种体裁,都在慢慢地形成与完善中。包括交响

曲、协奏曲以及声乐套曲的结构与整体性思维创作，都与今天我们所能看到的形态有所不同。而恰恰也是这个原因，早期音乐才成为每个学习欧洲音乐的学生所必须了解与认知的部分。无独有偶，莫扎特这部《欢腾喜悦》恰恰是他 17 岁时在米兰创作的。当时，莫扎特和著名的阉人歌手 Venanzio Rauzzini（同时是钢琴家和作曲家）是好友，因此为他量身定做了这部作品。并且，由于这部作品中的每首曲目又在形式上与莫扎特的音乐会咏叹调类似，因此成为后来很多女高音在不同场合演出时的重要可选曲目之一。

鉴于自身的学习经历，加之国内对该套曲目的研究成果相对较少，所以我有意就莫扎特及其创作，结合这部作品在音乐本体上进行分析。本书从音乐的本身出发，在进行深入分析的基础之上，配合该套曲在语言、行韵和音乐处理上进行解读，同时考量声乐套曲在欧洲的发展历程。总之，本书旨在围绕该作品进行最大程度上的引申，以帮助更多学习声乐的人了解早期音乐演唱中应当注意的各种相关问题。

<div style="text-align:right">李梦石</div>

# Foreword

Mozart was a pivotal figure in the historical development of Western music. In his brief life of just over three decades, he revolutionized the European music scene with his extraordinary creative prowess, and his enduring influence persists to this day. On the occasion of the 270th awniversary of this birth, I approach the musical legacy crafted by this eminent composer from a fresh perspective. Throughout his lifetime, Mozart explored various genres of music, including symphonies, sonatas, concertos, chamber ensembles, opera, art songs, oratorios, and more. Among his extensive oeuvre, his vocal compositions stand out, cherished by subsequent generations of singers for their highly expressive language, intricate melodies, and diverse musical styles. One such vocal suite is Work K.165, composed by Mozart in 1773. This period marked the zenith of Mozart's creative output, and he approached this vocal composition with fervor, showcasing an early mastery of musical expression.

My opportunity arose during the final exams of her second year of graduate studies at the Milan Conservatory of Music. At this time, the school stipulated that each student should sing a piece from the early periods. Having previously studied and performed one of Mozart's suites, K.165, which was included in vocal textbooks for higher education institutions in China, I was familiar with it. Therefore, my mentor suggested that I perform the entire piece. The learning

requirements at the Milan Conservatory of Music generally necessitate performing the entire piece rather than just a single part. In this context, I embarked on a journey of learning under the mentor's guidance, not only preparing for exams but also engaging in various artistic practices on different occasions.

The development of early Western music was a crucial stage in the formation of composition and composition theory for later generations. The music of this era was characterized by a rich interplay of various musical elements, contributing to the gradual refinement and establishment of genres that we now enjoy. The structure and holistic approach to symphonies, concertos, and vocal suites differed from contemporary compositions, making early music essential for every student majoring in European music to understand and appreciate. Coincidentally, Mozart composed *Exsultate, Jubilate* in Milan at the age of 17. During this time, Mozart befriended the renowned castrati Venanzio Rauzzini, who was also a pianist and composer. Mozart tailored this piece specifically for Rauzzini. Due to its resemblance to Mozart's concert arias in form, each song in this work has become an important optional repertoire for many soprano performances on various occasions.

Based on my own learning experience and the limited research on this cycle in China, I aim to analyze Mozart and his compositions in light of the musical ontology of this work. Beginning with a thorough examination of the music itself, this book will interpret the melodies in terms of linguistic expression, melodic contour, and musical structure, additionally, explore the evolution of vocal techniques in Europe. In a word, the goal of this book is to expand the scope of this study as much as possible, enabling a broader understanding of the various issues pertinent to early music performance for vocalists.

<div style="text-align: right;">Li Mengshi</div>

# 目 录

第 1 章　莫扎特的艺术生涯 ········· 001
  1.1　莫扎特职业生涯的头十年(1760—1770) ········· 002
  1.2　莫扎特职业生涯的第二个十年(1770—1780) ········· 006
  1.3　莫扎特职业生涯最后的十一年(1780—1791) ········· 010

第 2 章　《欢腾喜悦》的音乐分析 ········· 019
  2.1　《欢腾喜悦》和声分析 ········· 020
  2.2　《欢腾喜悦》曲式结构研究 ········· 026
  2.3　莫扎特的创作技法特征 ········· 036

第 3 章　《欢腾喜悦》的演唱心得 ········· 051
  3.1　女性演唱者的过去 ········· 051
  3.2　《欢腾喜悦》中的拉丁语 ········· 052
  3.3　《欢腾喜悦》的演唱提示 ········· 053

Chapter I　Mozart's Artistic Career ········· 057
  1.1　The First Decade of Mozart's Career (1760—1770) ········· 058
  1.2　The Second Decade of Mozart's Career (1770—1780) ········· 063

1.3 The Last Eleven Years of Mozart's Career (1780—1791) ·················· 069

**Chapter II  Musical Analysis of *Exsultate Jubilate*** ············· 080
    2.1  Harmony Analysis of *Exsultate Jubilate* ················ 081
    2.2  Research on the Form Structure of *Exsultate Jubilate* ·················· 090
    2.3  The Characteristics of Mozart's Creative Techniques ······ 107

**Chapter III  Singing Experience of *Exsultate Jubilate*** ········· 128
    3.1  The Past of Female Singers ················ 128
    3.2  Latin in *Exsultate Jubilate* ···················· 129
    3.3  Singing Tips of *Exsultate Jubilate* ···················· 131

参考文献 ·················· 136

附录 ·················· 138
    一、《欢腾喜悦》歌词大意 ················ 138
    二、《欢腾喜悦》乐谱 ················ 140

后记 ·················· 162
**Postscript** ·················· 163

/ 第 1 章 /

# 莫扎特的艺术生涯

沃尔夫冈·阿玛多伊斯·莫扎特于 1756 年 1 月 27 日出生于奥地利萨尔茨堡，于 1791 年 12 月 5 日逝世于维也纳。他是奥地利作曲家，是利奥波德·莫扎特之子。他的风格本质上代表了许多不同时期创作元素的综合，从 1781 年起，这些风格在他的维也纳岁月中融合成了一种习惯，在当今音乐界被视为维也纳古典主义的顶峰。他的音乐以其优美的旋律、优雅的形式以及丰富的和声和质感而著称，尽管他也植根于奥地利和南德的器乐传统，但仍然深受意大利歌剧的影响。他被认为是西方音乐史上最重要的作曲家之一。

莫扎特最初被称为乔安娜·克里斯托马斯·沃尔夫冈斯·提奥菲勒斯。名字中的前两个是记录了 1 月 27 日圣约翰·克里斯托姆的节日，而沃尔夫冈斯是他的外祖父的名字，提奥菲勒斯是他的教父——商人乔安娜·提奥菲勒斯·佩格迈尔的名字。莫扎特是父亲利奥波德·莫扎特和他的妻子玛丽亚·安娜的第七个也是最后一个孩子；在众多的兄弟姐妹中，也只有他和第四个孩子玛丽亚·安娜活了下来。莫扎特这个名字于 1331 年在费沙赫首次被记录为海因里希·莫扎特，因为莫扎特家族自 14 世纪起出现在奥格斯堡西南部的其他村庄尤其是海因伯格。这个家族的父系血统在一定程度上可以追溯到 1486 年居住在奥格斯堡地区的安德里斯·莫扎特。这个家族的几个早期成员是泥瓦匠（即建筑师）、建筑师、工匠和雕塑家。

## 1.1 莫扎特职业生涯的头十年(1760—1770)

莫扎特的早期教育完全来自其父亲利奥波德,不仅仅局限于音乐,还包括数学、阅读、写作、文学、语言和舞蹈等。另外,当时的宫廷歌手弗朗兹·安东·斯皮策也为年轻的莫扎特进行音乐指导。这位音乐神童在很小的时候就展示了他的音乐天赋;利奥波德在莫扎特姐姐的音乐书中指出,莫扎特在 4 岁的时候就学会了一些曲目——大部分是不知名的小步舞曲。这些音乐可能源自德国,但也包括瓦根塞尔、C.P.E.巴赫、J.J.阿格雷尔和 J.N.蒂舍尔以及利奥波德·莫扎特本人的作品。根据利奥波德的说法,莫扎特已知的最早作品,是一首小型行板和快板,创作于 1761 年,当时他只有 5 岁。而更重要的作品是 F 大调编号 K.2 和 K.5 的两部小步舞曲,以及创作于 1762 年 1 月至 7 月 B 大调编号 K.3 的快板。

莫扎特第一次公开露面是在 1761 年 9 月,当时他参加了萨尔茨堡大学玛丽安·维默的期末戏剧中的 *Sigismundus Hungariae rex* 的表演,并由萨尔茨堡卡佩尔梅斯特·恩斯特·埃伯林演奏。1762 年,利奥波德带着莫扎特和姐姐去了慕尼黑,在那里他们为巴伐利亚州的马克西米利安·约瑟夫三世弹奏了大键琴(这段旅程没有留下任何文献记载,是莫扎特姐姐的口述记录)。1762 年 9 月至 12 月,莫扎特一家的维也纳之行持续了一段时间。孩子们两次出现在玛丽亚·特蕾莎和她的配偶弗朗西斯一世前,也出现在各大使和贵族的家中,赚尽了风头。因此,这次旅行取得了巨大成功。其间,宫廷还向莫扎特夫妇颁发了一笔丰厚的酬金,并要求他们延长逗留时间。而法国大使弗伦特·路易斯·玛丽、洛蒙特城堡伯爵还邀请他们去凡尔赛。

1763 年 1 月 5 日,莫扎特全家返回萨尔茨堡。莫扎特的父亲利奥波德得到了晋升,并参加了当地举行的重大活动。在这一系列的活动中,莫扎特和姐姐都参与了音乐会的演奏,得到了家乡人的高度认可。6 月 9 日,全家人开始了为期三年半的欧洲旅程,途经德国、法

国、英国和瑞士等国家。

莫扎特一家于 1763 年 10 月 4 日抵达布鲁塞尔,途经慕尼黑、奥格斯堡、路德维希堡等地。在这些地方,莫扎特一家以各种形式进行表演,多次举办公开音乐会。1764 年 1 月 1 日,在法国巴黎,孩子们在路易十五面前演奏,随后于 3 月 10 日和 4 月 9 日在圣奥诺雷街的 Mélix 私人剧院举行了公开音乐会。在巴黎期间,旺多姆夫人出版了莫扎特的两首键盘和小提琴奏鸣曲,作品编号为 K.6—9,这是他首次被出版的音乐。莫扎特一家于 4 月 23 日抵达英国,为乔治三世演奏了音乐作品,并计划于 5 月 23 日出席作曲家和大提琴家卡洛·格拉齐亚尼的义演。然而,由于当时莫扎特忽然病倒,此次义演并没有成行。为此,利奥波德夫妇于 6 月 5 日在春天花园的大房间举行了自己的慈善活动。

莫扎特夫妇于 1765 年 7 月 24 日离开伦敦,途经坎特伯雷和里尔,前往根特和安特卫普,于 9 月 10 日抵达海牙。在那里,他们举行了两场公开音乐会,并在拿骚·韦尔堡公主面前演奏,莫扎特后来为她创作了键盘和小提琴奏鸣曲 K.26—31。3 月 11 日,莫扎特回到海牙,为威廉五世的装置作品创作了《加里马提亚音乐》(*Gallimathias musicum*,作品编号 K.32)。4 月,他们再次前往巴黎,5 月初抵达巴黎,莫扎特夫妇在巴黎逗留了两个月。他们的赞助人格林男爵早先在那里为莫扎特铺平了道路,给予了他高度的社会评价。

之后,莫扎特一家踏上了归途。途中,莫扎特夫妇前往第戎、里昂、洛桑、苏黎世和多瑙申根,在那里他们为弗斯滕贝格王子演奏了九个晚上。他们从多瑙申根出发,前往迪林根、奥格斯堡和慕尼黑,于 11 月 29 日抵达萨尔茨堡。

利奥波德·莫扎特通常被认为是一个固执的、要求完美的演出经纪人,但事实上,他们的大部分盛大演出都没有提前计划。当利奥波德离开萨尔茨堡时,还没有决定是否前往英格兰。但莫扎特在伦敦的受欢迎程度可能超过了他们的预期。直到 1765 年 6 月,他们被迫在康希尔的低端市场进行廉价的公开展演。不过,人们并没有普遍意识到当时的旅行有多么困难。例如,行走的路线往往不安全,而

且旅途中颠簸不舒服。一般来说,当时巡演旅途的费用比较高昂。况且他还经常会受到阻碍,被潜在的同行抵制或阻止表演。尽管如此,由于一些意外所导致的线路变化,巡演增加了近两年的时间,但也获得了丰厚的音乐收益。在他们旅行的每一个阶段,莫扎特都能获得在萨尔茨堡难以获得的音乐,或遇到通常不在德国南部和奥地利旅行的作曲家和表演者,这进一步拓宽了他的眼界。在路德维希堡,他们听到了纳迪尼。在巴黎,他们遇到了舒伯特、埃卡德和霍诺尔,欣赏了他们的奏鸣曲以及劳帕赫和 C.P.E. 巴赫的作品。莫扎特后来选择了由此获得的灵感而创作了编号为 K.37、K.39、K.40 和 K.41 的协奏曲。他们在伦敦的逗留使莫扎特与 K.F.Abel、Giovanni Manzuoli 以及最为重要的 J.C.Bach 有了接触,与他们建立了亲密关系。无疑他们对莫扎特的影响是终生的。

可以肯定地说,在整个旅行的"大巡演"中,莫扎特开始吸收父亲对各种民族风格的理解以及学习如何在公共场合表达自己的意见。也许更重要的是,莫扎特也铭记了父亲对萨尔茨堡的负面看法,在他 17 世纪 70 年代末和 80 年代初的信中几乎一字不差地重复了这些看法。

莫扎特在萨尔茨堡待了九个月。在此期间,他创作了三部声乐作品:一部拉丁喜剧《阿波罗与风信子》,为萨尔茨堡大学创作;与迈克尔·海顿和安东·卡杰坦·阿德加塞尔共同创作了清唱剧 *Die Schuldiggeit des ersten Gebots* 的第一部分;以及 *Grabmusik*(作品编号 K.42)。1767 年 9 月 15 日,全家出发前往维也纳。据推测,利奥波德此次访问的时间恰逢 16 岁的大主教约塞法与那不勒斯国王费迪南德四世的婚礼。然而,约塞法感染了天花,并在婚礼举行的第二天去世,导致宫廷进入哀悼期。这迫使利奥波德将家人从维也纳改道前往布吕恩(布尔诺),然后去奥卢穆茨(奥洛穆茨),也是在这个时候,莫扎特和南内尔都在那里患了轻微的天花。

1768 年 12 月 10 日,《维也纳日记》曾经报道莫扎特的作品获得了最为普遍的掌声和赞赏,并以最准确的方式得到了演绎。此外,就在这个月,他完成了编号 K.48 交响曲。

他们于 1769 年 1 月 5 日回到家，在那里待了将近一年。莫扎特于 10 月为他的朋友卡杰坦·哈格纳尔庆祝仪式创作了其作品编号为 K.66 的作品。这一时期他的其他重要作品还包括三首管弦曲，分别是编号 K.63、K.99 和 K.100。其中有两首可能是为了在大学传统的年终典礼上进行最后表演的压轴音乐。另外还有编号 K.117 和 K.141，以及几组舞蹈小步舞曲 K.65a 和 K.103、K.104 和 K.105。莫扎特 13 岁时，已经在当地赢得了作曲家和表演者的盛誉。10 月 27 日，他被任命为萨尔茨堡法院名誉法官。

在将近两个月之后，也就是 1769 年的 12 月 13 日，莫扎特父亲利奥波德和莫扎特前往意大利。这次旅行遵循了常规表演的模式，他们在任何可以举办音乐会的城镇或莫扎特有望为有影响力的贵族演奏的地方停留。他们途经因斯布鲁克和罗维雷托，于 12 月 27 日抵达维罗纳。在那里，莫扎特在费拉莫尼卡学院演奏。1770 年 1 月 16 日，莫扎特在曼图亚举行了一场音乐会，这场音乐会是他当时演出的典型代表。曲目包括他创作的交响乐、协奏曲、奏鸣曲、赋格曲、变奏曲和咏叹调的正式演奏，以及他本人的即兴表演。《曼托瓦报》在一份关于音乐会的报道中称莫扎特的音乐"无与伦比"。

在此之后，莫扎特夫妇从曼图亚前往米兰，莫扎特在奥地利公使卡尔·菲尔米安伯爵的家中进行了几场演出。大概是由于他的表演和作曲所带来的影响，莫扎特受委托为 12 月的狂欢节创作第一部歌剧《米特里达特》。莫扎特父子于 3 月 15 日离开米兰，前往洛迪，莫扎特在那里完成了他的第一首弦乐四重奏，编号 K.80。之后前往帕尔马、博洛尼亚和佛罗伦萨，莫扎特与阉人歌手曼佐利结识，并与英国作曲家托马斯·林利结识。他们从那里前往罗马，于 4 月 10 日抵达米兰，在那里他创作了三首交响曲，即作品编号 K.81、K.95 和 K.97。在那不勒斯短暂逗留期间，莫扎特举办了几场音乐会，并聆听了乔梅利的《阿米达》。莫扎特父子 7 月 10 日从罗马出发，返回博洛尼亚和帕拉维奇尼伯爵的避暑别墅。莫扎特在那里完成了编号为 K.84 的交响曲。

## 1.2　莫扎特职业生涯的第二个十年（1770—1780）

1770年10月18日，莫扎特夫妇返回米兰后，歌剧《米特里达特》的作曲工作正式开始。在之后的时间，该歌剧进行了多次彩排，两次管弦乐队预演，两次完整的剧院彩排。关于当时乐队的编制，莫扎特的父亲利奥波德在12月15日的信中提供了有用的信息，即乐团由14把第一小提琴和14把第二小提琴、6把中提琴、2把大提琴、6把低音提琴、2支长笛、2支双簧管、2支低音管、2支小号和2个键盘等乐器组成。首演于12月26日在Regio Ducal Teatro举行；包括芭蕾舞音乐在内，歌剧持续上演了6个小时。虽然利奥波德并不相信这部歌剧会成功，但事实证明他的判断错了，莫扎特这部歌剧获得了空前的成功，以至当时直接上演了22场之多。

莫扎特于1771年1月14日离开米兰，途经都灵、威尼斯、帕多瓦和维罗纳，然后于3月28日返回萨尔茨堡。15个月的意大利之旅取得了非凡的成功，国际媒体对此进行了广泛的报道。汉堡国家歌剧院在5月22日从罗马发出的一份报告中描述了莫扎特"非凡而早熟的音乐天赋"。有报纸对1771年3月5日莫扎特威尼斯音乐会进行了报道，还总结了他这次巡演的专业和个人成就。

其实，在1771年3月，他们回到萨尔茨堡之前，利奥波德就已经计划好了之后的两次意大利之旅。关于这两次旅行，莫扎特夫妇在维罗纳时，莫扎特受委托为第二年10月在米兰举行的摩德纳大公费迪南德和玛丽亚·比阿特丽斯·里恰尔达公主的婚礼创作一首小夜曲，名为《阿尔巴的阿斯卡尼奥》；就在同一个月，米兰地区公爵剧院向他发出了1773年第一部狂欢节歌剧《卢西奥·西拉》的创作合同。所以，莫扎特在1771年仅在家中度过了5个月的时间，在此期间，他创作了《帕杜安清唱剧》《雷吉娜·科利》（编号K.108）《利塔尼》（编号K.109）和《交响曲》（编号K.110）。8月13日，莫扎特父子再次出发，8月21日抵达米兰。8月29日，他们在阿尔巴收到了朱塞佩·帕里尼为阿斯卡尼奥创作的歌词。在米兰，莫扎特的小夜曲于9

月27日进行排练,并于10月17日首演。之后,莫扎特一直留在米兰,直到12月5日,他创作了名为《潜水员协奏曲》编号K.113和《交响曲》编号K.112的作品。他曾试图在宫廷里寻求一份工作,但他的申请实际上被费迪南德的母亲玛丽亚·特蕾莎皇后拒绝了。

莫扎特的第三次也是最后一次意大利之旅于1772年10月24日开始。莫扎特在夏天收到了米兰新歌剧《卢西奥·西拉》的剧本和演员名单,并且为此还安排了朗诵会。在他抵达米兰时,新歌剧做了部分调整,以适应诗人乔瓦尼·德·加梅拉为演出所做的修改。然后,莫扎特写了合唱部分,并为歌手们依次谱写了咏叹调。在创作的过程中,莫扎特先是听了他们的每一首歌曲,这样他就可以将音乐与他们的声音进行较好的匹配。事实上,这部歌剧在12月26日的首次演出后取得了喜忧参半的效果,主要是因为演员阵容参差不齐,水平不一。尽管如此,这部歌剧在此上演了26场。

1773年3月13日,利奥波德和莫扎特回到了萨尔茨堡。也就是在这个时候,所谓的莫扎特神童时代就逐渐远去了。虽然他后来也去了维也纳、慕尼黑,甚至去了曼海姆和巴黎,但毫不夸张地说,18世纪70年代是由他在萨尔茨堡的任意支配时代。在很大程度上,他作为表演者和作曲家的职业生涯都集中在他的宫廷活动和家乡的一小部分朋友和赞助人身上。

1775年,科洛雷多下令重建汉尼拔加滕的鲍尔豪斯剧院,费用由该市承担,作为话剧和歌剧的剧院。第一个在那里演出的剧团由卡尔·沃尔执导,其剧目包括喜剧《泽斯特鲁特》(以J.F.Regnard命名),由约瑟夫·海顿配乐(第60交响曲,《伊尔迪斯特拉托》)。而格布勒的悲剧《塔莫斯》则是由莫扎特配乐。1780年,希卡内德的剧团到访,莫扎特为此创作了咏叹调。

莫扎特在1772年至1774年间创作了大量的作品。其中包括编号K.167、K.192、K.194、K.125和K.195,雷吉娜·科利K.127、十几首交响乐(从K.124到K.202)、键盘协奏曲K.175(可能是风琴协奏曲)和小提琴独奏曲K.190、小夜曲K.203、套曲K.131、K.166和K.205以及K.174五重奏。1773年底,莫扎特一家从他们在盖特雷德加塞的

公寓搬到了汉尼拔广场（现在的马卡特广场）的一个更大的公寓，也就是所谓的坦茨梅斯特豪斯。毫无疑问，这一举动反映了利奥波德意识到自己在萨尔茨堡社会中的地位。这家人社交活跃，参加射击派对，不断创作音乐，经常接待来访者。莫扎特的父亲于1773年7月带莫扎特去了维也纳。在维也纳四个月的日子对莫扎特来说是一次富有成效的旅行。他创作了一首小夜曲 K.185 和六首弦乐四重奏（K.168—K.173）。四重奏其中的两首 K.168 和 K.173，所散发的强烈风格传统上被认为是莫扎特与约瑟夫·海顿带有引领性的四重奏，它们反映了当时维也纳四重奏的共同创作风格。

莫扎特于9月下旬从维也纳返回故乡，除了1774年12月至1775年3月期间在慕尼黑度过的3个月的创作和首演外，他一直留在家乡，直到1777年9月。大约在这个时期，莫扎特开始逐渐退出萨尔茨堡宫廷音乐，家族之间的通信记录了利奥波德沮丧地无法为他们找到合适职位的困扰。在意大利1770年到1771年的两年和维也纳的1773年，利奥波德都试图找到能让家人离开萨尔茨堡的工作，这已经不是他第一次有这样的想法了。

而莫扎特专心创作这件事是没有受到影响的。这是所有萨尔茨堡作曲家的首要职责。他在1775年至1777年间的作品，包括编号 K.220、K.257、K.258、K.259、K.262、K.275、K.243 和奉献 K.277。莫扎特成为萨尔茨堡器乐和世俗声乐的首席作曲家。他的四首小提琴协奏曲编号 K.211、K.216、K.218 和 K.219 和四首键盘协奏曲编号 K.238、K.242、K.246、K.271，小夜曲 K.204 和 K.250，*Serenata notturna* K.239 和许多套曲包括 K.188、K.240、K.247 和 K.252，都可以追溯到这个时期。他还创作了几首咏叹调，包括 *Si mostra la sorte* K.209、*Con ossequio*、*Con rispetto* K.210、*Voi avete un cor fedele* K.217 和 *Ombra felice ... Io ti lascio* K.255。莫扎特对器乐的培养很可能受到了利奥波德的鼓励。在许多情况下，他是为私人赞助人而不是宫廷创作的。利奥波德在其全盛时期是当地最杰出、最成功的交响乐和小夜曲作曲家。

1777年夏天，利奥波德觉得自己负担不起离开萨尔茨堡的费

用，于是莫扎特于9月23日与母亲一起离开家乡再次旅行。这次旅行的目的很明确，莫扎特是为了获得高薪工作，这样一家人就可以搬家了。莫扎特与慕尼黑方面进行接触，但遭到了礼貌的拒绝。在奥格斯堡，莫扎特举办了一场音乐会，上演了包括他最近的几部作品，并结识了键盘乐器制造商 J.A. 斯坦因。

莫扎特和他的母亲从奥格斯堡前往曼海姆，在那里他们一直待到三月中旬。他在曼海姆创作的作品包括键盘奏鸣曲 K.309 和 K.311，长笛四重奏 K.285，五首伴奏奏鸣曲 K.296、K.301、K.302、K.303、K.305 和两首咏叹调，*Alcandro lo deplaito … Non såd'onde viene* K.294 和 *Se al labbro mio Non-credi … Il cor dolente* K.295。当时荷兰东印度公司的一名员工 Ferdinand Dejean 曾在东亚担任医生多年，他想委约莫扎特创作三首长笛协奏曲和两首长笛四重奏，但最终未能达成心愿，莫扎特只创作了一首四重奏。而咏叹调 K.294 是为曼海姆抄写员弗里多林·韦伯的女儿阿洛伊西亚·兰格创作的。那是因为，莫扎特爱上了阿洛伊西亚，他向利奥波德提出了带她去意大利成为首席女高音的想法。但这个提议激怒了莫扎特的父亲，他指责莫扎特拖沓、对金钱不负责任和对家庭不忠。

1778 年 2 月，利奥波德命令他的儿子前往巴黎，并决定让他的母亲继续陪伴他，而不是回到萨尔茨堡。这一决定将对父子俩产生了深远的影响。莫扎特于 3 月 23 日抵达巴黎，并立即与格林重新建立了联系。他为霍尔茨鲍尔的《悲惨世界》表演创作了额外的音乐，主要是合唱作品 kA1。6 月 18 日，在 Spirituel 音乐会上演奏了莫扎特的一首交响乐作品，编号 K.297。而他为 Noverre 创作的一组芭蕾作品 *Les petits riens* 则与 Piccinni 的歌剧 *Le finte gemelle* 一起演奏。莫扎特在巴黎很不开心，而他的母亲在 6 月的中旬生病了，并于 7 月去世了。他的父亲利奥波德含蓄地暗示莫扎特对他母亲的死亡负有部分责任。

莫扎特在格林家度过了这个夏天的剩余时间。9 月 8 日，他在 Spirituel 音乐会上演奏了另一首交响乐，并认识了 J.C. 巴赫。巴赫在创作歌剧《阿玛迪斯·戴高乐》之前，是从伦敦来听巴黎歌手演唱的。

莫扎特于9月26日启程回家。格林让他乘坐慢车穿过南希,途经斯特拉斯堡到曼海姆,在那里他听到了本达的情节剧《美狄亚》。然而,利奥波德对莫扎特去了曼海姆感到愤怒,因为卡尔·西奥多的宫廷被转移到慕尼黑后,那里就没有晋升的机会了。莫扎特于12月25日抵达慕尼黑,并一直待到1月11日。他受到了阿洛伊西亚·韦伯的冷遇,因为她正在宫廷歌剧中演唱。最后,在1779年1月的第三周,他回到了萨尔茨堡。

莫扎特回国后立即向宫廷正式请愿,要求任命他为宫廷风琴师。他的职责包括在宫廷演奏,并指导唱诗班男孩演唱。他一开始似乎坚定地履行了自己的职责,1779—1780年,他创作了《加冕》K.317、K.337、K.321和K.339以及《雷吉娜·科利》K.276。莫扎特还创作了双钢琴协奏曲K.365、钢琴和小提琴奏鸣曲K.378;交响乐K.318、K.319和K.338;*Posthorn*小夜曲K.320和套曲K.334;小提琴和中提琴协奏曲K.364,以及*Thamos, King in Egypt*和*Zaide*的附带音乐。

## 1.3 莫扎特职业生涯最后的十一年(1780—1791)

1780年夏天,莫扎特受委托为慕尼黑创作一部严肃的歌剧,并于11月6日抵达慕尼黑。这部歌剧最终于1781年1月29日首次上演,并取得了相当大的成功。来自萨尔茨堡的利奥波德和南内尔都出席了首演。之后,莫扎特一家一直留在慕尼黑,直到3月中旬。在此期间,莫扎特创作了朗诵和咏叹调《悲惨世界》K.369、双簧管四重奏K.370,还有三首钢琴奏鸣曲K.330、K.331和K.332。3月12日,莫扎特被召集前往维也纳,庆祝约瑟夫·二世皇帝登基。他于3月16日抵达,刚刚在慕尼黑取得胜利的莫扎特因被当作仆人对待而感到愤怒。

大约在这个时候,莫扎特搬到了他在曼海姆的前朋友韦伯家,他们在阿洛伊西亚与宫廷演员约瑟夫·兰格结婚后搬到了维也纳。起初,莫扎特收入微薄,教过三四名学生,其中包括约瑟法·冯·奥恩哈默尔,他为她写了两首钢琴的奏鸣曲K.448。他教过的学生中还有

玛丽·卡罗林,蒂埃内斯·德·伦贝克伯爵夫人,以及外交大臣约翰·菲利普·冯·科本策尔伯爵的堂兄。莫扎特还参加了各种音乐会,或在音乐会上表演作品。4月3日,德国音乐协会发表了他的一首交响乐。11月23日,他在由约翰·迈克尔·冯·奥恩哈默尔赞助的一场音乐会上演奏。后来,莫扎特参加了菲利普·雅各布·马丁举办的一系列奥加滕音乐会。1782年5月26日,在第一场音乐会上,他与约瑟法·冯·奥恩哈默尔演奏了一首双钢琴协奏曲。莫扎特在这里开的专场音乐会第一场于1782年3月3日在伯格剧院举行,音乐会节目包括协奏曲 K.175、K.382 和 K.415。他还定期在戈特弗里德·范·斯威滕男爵的家中演奏,亨德尔和巴赫的作品是那里的主要演奏曲目。

到1781年底,莫扎特已经成为维也纳最优秀的键盘演奏家。虽然他并非没有对手,但很少有人能与他的钢琴技艺相媲美。最严峻的挑战可能来自克莱门蒂,12月24日,在奥地利皇帝约瑟夫二世的授意下,莫扎特与克莱门蒂参加了一场非正式的比赛。很明显,莫扎特对这一事件感到不安。尽管人们认为他赢了,克莱门蒂后来也慷慨地谈到了他的演奏,但莫扎特在信中一再贬低这位意大利钢琴家。克莱门蒂的技巧很可能让莫扎特大吃一惊,皇帝一定也印象深刻,因为他在一年多的时间内一直在谈论这场比赛。同月,莫扎特的第一本维也纳出版物也发表了,这是一套六首键盘和小提琴奏鸣曲编号 K.296、K.376、K.377、K.378、K.379、K.380 的作品合集。他们受到了好评,C.F.克雷默的《博物馆杂志》(1783年4月4日)中的一篇评论将它们描述为"同类中独一无二的",充满了新思想和伟大音乐天才的痕迹。

这一时期最重要的作品是 *Serail Entführung aus dem Serail*,其歌词于1781年7月底交给了莫扎特。原定于9月举行的首演被推迟到次年夏天(莫扎特于1781年8月完成了第一幕)。歌剧取得了巨大成功。因此,格鲁克要求进行额外的加演。席坎德尔的剧团于1784年9月进行了独立演出。

也就是在这个时候,莫扎特决定与康斯坦泽·韦伯结婚。1782

年 7 月 31 日，莫扎特写信给他的父亲，请求他的批准，8 月 4 日，他们在斯蒂芬多姆举行了婚礼。利奥波德直到第二天才勉强同意。这段婚姻看起来很幸福。尽管莫扎特形容康斯坦泽缺乏智慧，但他也认为她"有足够的常识和世界上最善良的心"。他写给她的信，尤其是 1789 年他巡回演出时和 1791 年给妻子在巴登接受治疗时写的信，都充满了爱。

莫扎特在 1782 年到 1783 年间，还创作了几首新作品，包括后来由 Artaria 出版的钢琴协奏曲 K.413、K.414、K.415，尽管莫扎特可能没有将其视为一套，但在 1783 年春天，他将这三首曲子彻底修改，并到一起。这个时候他还创作了三首咏叹调 K.418、K.419、K.420。他计划于 1783 年 6 月 30 日在伯格剧院制作帕斯夸尔·安福西的 *Il curioso increto*。同时，他开始创作所谓的"海顿"四重奏。第一首 K.387 于 1782 年 12 月完工；第二首是 K.421，于 1783 年 6 月完成，而此时康斯坦泽正在生下他们的第一个孩子，6 月 17 日雷蒙德·利奥波德出生。莫扎特和康斯坦泽有六个孩子，其中四个在婴儿期死亡，他们分别是雷蒙德·利奥波德（1783）、卡尔·托马斯（1784）、约翰·托马斯·利奥波德（1786）、特蕾西娅（1787—1788）、安娜·玛丽亚（1789）和弗兰兹·泽弗·沃尔夫冈（1791）。

莫扎特和康斯坦泽最终于 1783 年 7 月出发去往家乡。他们在萨尔茨堡停留了大约 3 个月。后来的信件表明，这次访问并不完全愉快——莫扎特对这次访问以及他父亲对康斯坦泽的反应感到焦虑。在那里，他为迈克尔·海顿创作了两首小提琴与中提琴二重奏。在返回维也纳的途中，莫扎特在林茨停留，在那里他为一场音乐会创作了一首交响乐编号 K.425，钢琴奏鸣曲 K.333 也是从这个时候开始创作的。

1783 年 11 月下旬，莫扎特回到维也纳，开始了他一生中最繁忙、最成功的几年。12 月 22 日，他在 Tonkünstler Societät 举办的音乐会上演奏了一首协奏曲；1784 年 1 月 25 日，他为阿洛伊西亚·兰格指挥了一场 *Die Entführung* 的演出。3 月，他在特拉特纳霍夫的私人大厅举办了三场音乐会。4 月 1 日，他在伯格剧院举办了一场盛大的音

乐会，演出的节目包括一首交响乐（《林茨》编号K.425）、一首新的协奏曲（K.450 或 K.451）、钢琴和管弦乐五重奏K.452以及即兴创作与演奏。1785 年的演出季也类似。从 2 月 11 日开始，他在梅尔格鲁贝举行了六场音乐会，演出了包括 D 小调协奏曲 K.466 在内的作品。3月 10 日，他在伯格剧院举行了另一场大型音乐会。从 1784 年 2 月至 1786 年 12 月，莫扎特创作了十几首钢琴协奏曲，这无疑是同类作品中最重要的作品。也许是为了表彰他的后起之秀，1784 年 2 月，莫扎特开始保存他的新作品 Verzeichnüss aller meiner Werke 的目录，记录每一部作品的主题和日期。该目录是有关莫扎特在 18 世纪 80 年代创作活动的主要信息来源，记录了几首遗失的作品，包括咏叹调 K.569、K.565 和小提琴协奏曲 K.470 的行板。

除了公开演出外，莫扎特还参加了私人音乐会。仅在 1784 年 3 月，他就演奏了 13 次，主要是在约翰·埃斯特哈齐伯爵和俄罗斯大使戈利茨亲王的家中。出于同样的原因，当地的演奏家和音乐会组织经常在他们的节目中推出他新委托的作品。3 月 23 日，单簧管演奏家安东·斯塔德勒演奏了《风小夜曲 K.361》；4 月 29 日，莫扎特和小提琴家里贾娜·斯特里纳萨奇演奏了《奏鸣曲 K.454》。这些作品和表演给莫扎特带来了相当大的赞誉。利奥波德·莫扎特于 1785 年 2 月和 3 月访问了维也纳的儿子，他写信给南内尔，描述了在莫扎特家中举行的四重奏派对。海顿在派对上告诉他："在上帝面前，作为一个诚实的人，我告诉你，你的儿子是我所知道的最伟大的作曲家，无论是从个人还是从名字上。他有品位，更重要的是，他有着最渊博的知识。"

莫扎特在这一时期出版了很多作品，其中包括在托里切拉演奏的三首奏鸣曲 K.333、K.284 和 K.454。1784 年 7 月，劳施为六首钢琴协奏曲的手稿做了广告；1785 年 2 月，特拉格提供了三部交响乐的复制稿。然而最重要的出版物可能是 Artaria 于 1785 年 3 月出版的三首协奏曲 K.413、K.414 和 K.415，以及 Artaria 在同年 9 月出版的献给海顿的六首四重奏。这些作品的成功似乎使莫扎特对作曲和出版的态度发生了根本性的转变。1786 年中期之后，莫扎特计划了几

部作品，主要是为了出版，而不是公开表演，其中包括钢琴四重奏 K.478 和 K.493，钢琴三重奏 K.496、K.542 和 K.548，C 大调和 G 小调弦乐五重奏 K.515 和 K.516，霍夫梅斯特四重奏 K.499，以及钢琴和小提琴奏鸣曲 K.526。

尽管在这一时期，歌剧一直是莫扎特野心的核心，但他没有机会在 Die Entführung 的成功基础上得到突破。到 1782 年末，约瑟夫二世决定关闭国家剧院（他于 1776 年创立该剧院，以促进德语文化的发展），并重新建立意大利歌剧。莫扎特很快就利用了这一变化，尽管他很难找到合适的剧本。因此，他要求利奥波德请萨尔茨堡诗人、伊多梅内奥的剧作家瓦雷斯科提供一部剧本。1786 年初，在 Schloss Schönbrunn 的橘园上演了一部独幕喜剧 Der Schausfieldirektor K.486，以及萨列里的《音乐之首》（这两部都是受奥地利-荷兰总督委托演出的）。3 月，他在 Auersperg 王子剧院举行了一场 Idomeneo 修订版的私人演出。除了其他变化外，莫扎特创作了二重唱 Spiegarti non-poss'io（K.489）来代替 S'io non-moro a questi accenti，并创作了场景和 rondànon-piú, tutto ascoltai … non-temer, amato bene（K.490）来代替第二幕的原始开头。

莫扎特与洛伦佐·达·庞特首次合作的主题，无疑是经过精心挑选的。莫扎特于 1785 年 10 月和 11 月开始创作《费加罗的婚礼》，1786 年 5 月 1 日，该歌剧登上了勃艮第剧院的舞台首次上演。最初的演出取得了成功。在前三场演出中，许多曲目都得到了掌声，这促使皇帝将后来的再演限制在咏叹调上。这部歌剧中所谓的煽动性可能被夸大了。Da Ponte 谨慎去除了 Beaumarchais 戏剧中更具煽动性的元素，使歌剧中的人物和事件完全符合艺术传统。尽管如此，反映社会紧张局势的内容依然存在，如第二幕的结局和第三幕早期的音乐。而个别咏叹调也反映了各个角色的社会地位。然而，最终《费加罗的婚礼》只不过是一部喜剧性的国产剧，尽管它反映了当时人们对性别和社会的担忧。

莫扎特最初是通过招收学生来维持他在维也纳的生活，其中最重要的学生是约翰·内波穆克·胡默尔，他在 1786 年至 1788 年跟

随莫扎特学习。莫扎特还教过英国作曲家托马斯·阿特伍德,他保留下来的练习册证明了莫扎特谨慎、系统的教学方法。

1787 年莫扎特接受了前往布拉格的邀请,《费加罗的婚礼》在那里取得了巨大成功。从 1787 年 1 月 11 日起,他在那里待了大约四周,显然很享受自己在这座城市的受欢迎程度。他指挥了一场《费加罗的婚礼》的演出,并举办了一场音乐会,其中包括为这一场合创作的一首新交响曲——布拉格 K.504。就在这个时候,布拉格的经理人帕斯夸尔·邦迪尼委托莫扎特为第二年秋天创作歌剧。回到维也纳后,莫扎特向杜邦索要了文本唱词。

《唐·乔瓦尼》的情节与《费加罗的婚礼》一样,都以阶级和性别的紧张关系为基础,这一主题至少可以追溯到蒂索·德·莫利纳(1584—1648)时期。尽管达庞特借鉴了最新的舞台版本,一部由朱塞佩·加扎尼加音乐创作的独幕歌剧和乔瓦尼·贝尔塔蒂于 1787 年 2 月在威尼斯创作的剧本。莫扎特于 10 月 1 日启程前往布拉格,首演原计划于 1787 年 10 月 14 日举行,但由于准备不足,《费加罗的婚礼》的演出被迫取消,而新歌剧上演被推迟到 10 月 29 日,一经上演,就受到了热烈欢迎。莫扎特在 11 月中旬返回维也纳之前指挥了三四场演出。在这段时间里,他还拜访了他的朋友杜塞克一家。他为萨尔茨堡的老朋友 Josefa 写了咏叹调 Bella mia fiamma K.528。《唐·乔瓦尼》于 1788 年 5 月在维也纳上演,并进行了几次改编:第二幕中莱波雷洛的逃跑咏叹调被与泽琳娜的二重唱所取代;第二幕中"Il mio tesoro"被第一幕中的"Dalla sua pace"取代,Elvira 获得了一首华丽的朗诵和咏叹调。

两部与杜邦合作的歌剧,再加上他的出版物越来越成功,开启了莫扎特职业生涯的新阶段。1786 年 4 月 7 日,在《费加罗的婚礼》首演前不到一个月,莫扎特在伯格剧院举办了一场大型音乐会,这是他在该场地的最后一场音乐会,上演了包括 C 小调钢琴协奏曲 K.491 在内的作品。莫扎特的父亲利奥波德·莫扎特于 1787 年 5 月去世,这为这位作曲家开启了一段休息时期。利奥波德的去世也标志着萨尔茨堡莫扎特家族的最终解体。当时,只有南内尔留下来了,她于 1784 年嫁给

了约翰·弗朗茨·冯·贝希托尔德·祖·索南堡，并搬到了圣吉尔根。除了处理他们父亲的遗产外，莫扎特显然没有与她保持联系。

莫扎特在维也纳的经济状况在一定程度上可以通过他在那里租的众多住所的位置和规模来衡量。1784年1月，他搬到了特拉特纳霍夫，并于同年9月搬到了位于市中心的一间公寓，即现在的Domgasse 5，靠近斯蒂芬大教堂。然而，到1788年中期，他搬到了遥远的郊区阿尔塞尔格伦，那里的租金要便宜得多。莫扎特在维也纳时期主要的收入来源包括公开音乐会的利润和私人赞助人的付款，以及从教学中赚的钱和出版物酬金，此外，还有从1788年起，他作为宫廷Kammermusicus所获得的薪水。莫扎特早年在维也纳的演出是一笔不错的收入来源。他1784年在古尔登6号吸引了100多名观众参加了三场音乐会。莫扎特于1789年春季，在莱比锡、德累斯顿和柏林进行了巡回音乐会，关于旅程的细节很少。在德累斯顿，他私下演奏室内乐，并在宫廷表演，此外还与管风琴师J.W.海斯勒一起参加了一场非正式的比赛。据报道，在莱比锡，他在托马斯基切管风琴上即兴演奏，当时坎特·J.F.多尔是巴赫的前学生。莫扎特可能在波茨坦和柏林卖出了一些作品，他还参加了 *Die Entführung* 的演出。

1789年，他的主要精力都放在了 *Così fan tutte* 的创作上，这是他与杜邦的第三次合作。歌词可能完全是莫扎特和诗人的原创，因为这个主题有时被声称是约瑟夫二世本人向莫扎特和达庞特提出的，据称是基于当时最近的一次现实事件。人们对这部歌剧知之甚少。它于1789年12月31日在莫扎特家中排练，1790年1月21日在剧院排练，首演则于1月26日举行。接下来的四场演出由于约瑟夫二世在2月去世而暂停。随着新皇帝利奥波德二世的登基，莫扎特希望在宫廷中获得晋升。

1790年9月，莫扎特带着他的妹夫弗兰兹·德·保拉·霍费尔和一名仆人前往法兰克福。他们于9月28日抵达，莫扎特于10月15日举行了一场公开音乐会，尽管在音乐上取得了成功，但观众人数很少，经济上也很失败。在回程中，莫扎特在美因茨举行了一场音乐会，在曼海姆听了《费加罗的婚礼》，并在慕尼黑的那不勒斯国王面

前演奏。11月10日左右，他回到家中，和康斯坦泽一起住在维也纳市中心的新公寓里，康斯坦泽刚刚搬到那里。在冬季的几个月里，他创作了钢琴协奏曲 K.595 和最后两首弦乐五重奏 K.593 和 K.614。他在单簧管演奏家 Josef Bähr 组织的音乐会上演奏了一首协奏曲，并在4月的 Tonkünstler Societät 音乐会上表演了一首咏叹调和一首交响乐。同一个月，莫扎特从市议会获得了在斯蒂芬大教堂担任 Kapellmeister 这一重要且有报酬的职位。当时在任的 Leopold Hofmann 年老多病，莫扎特被任命为助理和副手，没有薪水，但最终霍夫曼比他活得更长。

正是为了庆祝利奥波德二世在布拉格的加冕典礼，莫扎特创作了《铁托的克莱门扎》。在他去世后不久发表的报道表明，创作只写了18天，其中一些是在维也纳和布拉格之间的长途客车上写的。7月8日，经理人多梅尼科·瓜尔达索尼与波希米亚庄园签署了一份合同，他创作加冕歌剧的第一选择是萨列里。但萨列里拒绝了委托，这项工作落到了莫扎特的头上。莫扎特将铁托描述为"一部维拉歌剧"。首演于9月6日举行。

莫扎特的作品于1791年广泛出版。仅在那一年，维也纳经销商就制作了近十几个版本的莫扎特作品，所面向的观众远远超出了宫廷圈子。其中包括弦乐五重奏 K.593 和 K.614，安东·斯塔德勒的协奏曲 K.622, *Laut verkünde unsre Freude* K.623, 咏叹调 *Per questa bella mano* K.612、K.626,《Ave verum 音乐集》K.618, *Die Zauberflöte* K.620 和《安魂曲》K.624。正如给康斯坦泽的一封信中提到的那样，为伊曼纽尔·席坎德尔的郊区剧院 auf der Wieden 创作的 *Die Zauberflöte* 在6月11日已经顺利完成，除了序曲和进行曲这三个声乐项目外，作品可能在7月完成。这部歌剧有几个来源，其中包括利伯斯金的《露露》，发表在维兰德的童话集 *Dschinnistan*（1786—1789）中。

尽管这部歌剧广受欢迎——当代人对音乐的看法普遍赞同，但评论家们发现这部歌剧的文本并不令人满意。歌剧以一个传统故事开始，讲述了一位英雄王子（塔米诺饰）在母亲（夜女王）的命令下，

从邪恶的绑架者（萨拉斯特罗饰）手中救出了一位美丽的公主（帕米娜饰）。然而，在 Orator 的场景中，绑架者是仁慈的，而邪恶的是公主的母亲。塔米诺和帕米娜是寻求自我实现的理想存在。

可能在 7 月中旬，莫扎特受沃尔塞格·斯图帕赫伯爵的委托，为 1791 年 2 月 14 日去世的妻子创作了一首安魂曲。到莫扎特最后一次生病时，他只完成了《永恒安魂曲》；从 *Kyrie* 到 *Confutatis*，只有人声部分和低音连续音被完全写出。在 *Lacrimosa* 中，只有前八小节用于声乐部分，前两小节用于小提琴和中提琴。11 月底，莫扎特已经卧床不起。他由两位著名的维也纳医生 Closset 和 Sallaba 照顾。12 月 3 日，他的病情似乎有所好转。第二天，他的朋友 Schack、Hofer 和贝斯手 F.X.Gerl 聚集在一起，与他一起演唱了未完成的安魂曲的部分内容。然而，那天晚上，他的病情恶化了，他于 1791 年 12 月 5 日凌晨 1 点前去世。

12 月 7 日，根据当时维也纳人的习俗，莫扎特被安葬在城外的圣马克思公墓的一个普通坟墓里。这一天平静而温和，天才音乐家结束了自己光辉的一生。

/ 第 2 章 /

# 《欢腾喜悦》的音乐分析

莫扎特为了上演其"意大利创作时期"的最后一部歌剧《卢齐奥·希拉》,第三次到访了意大利米兰。在此停留期间,他创作了《欢腾喜悦》这部作品。这是莫扎特创作的一部经文歌套曲,也是他宗教声乐作品中最有名的一部。这部作品是由在《卢齐奥·希拉》中扮演切契利奥的阉人歌手费南奇欧·劳济尼在米兰的提亚其诺教堂首演。由于这部作品是为歌手拉兹尼而作的,所以也可视为一首量身定制的音乐作品。该作品的手稿目前收藏在柏林国家图书馆。

在意大利一共停留了 3 次共 22 个月的莫扎特,游历了意大利的大部分地区。比起在奥地利时,莫扎特在这期间创作了更多所谓世俗倾向的歌剧风格的教堂音乐。就这部作品而言,唯一的宗教因素只体现在拉丁文的歌词,其余所有移动的声部都具有歌剧的趣味。从乐曲的构成看,这部作品并未遵循当时经文歌的形式。它并非由两首咏叹调与两首宣叙调构成,最后以《阿利路亚》结束。这部作品只在第一乐章与第二乐章之间有一首宣叙调。如果去掉这个简短而具有连接功能的宣叙调,这部作品就形成了快—慢—快的乐章组合,体现了当时歌剧中的序曲或声乐协奏曲的强烈风格。

从某种意义上讲,这部作品并不能简单将其归纳为歌剧作品,因为这是一部独唱与乐队作品。而在莫扎特所有的独唱与乐队作品中,最著名的不是某一个乐曲,而是这首由女高音、乐队与管风琴演

奏的三个乐章组成的赞美诗。它是莫扎特早期声乐作品风格的最佳表现。末乐章的结束曲《阿利路亚》因其独特的风格和明快的节奏，在当时就成了经典乐曲，且延续至今已有二百多年。

这部作品可分为四个部分，其中具有三个风格不同的乐章。第一部分为第一乐章《你们欢呼雀跃吧》，这个乐章为快板乐章，调性为F大调。第二部分为宣叙调《白日闪烁出亮光》，它起到连接第一乐章与第二乐章的功能作用。第三部分为第二乐章《加冕的圣母玛利亚》，这个乐章为慢板乐章，调性为A大调，这里既不是属调，也不是下属调，而是使用了令人耳目一新的三度关系的A大调。第四部分为第三乐章《阿利路亚》，这个乐章为快板乐章，调性为F大调。乐曲整体是一个快、慢、快的乐曲结构，而这种结构更多见于大型的声乐及器乐协奏曲中。

## 2.1 《欢腾喜悦》和声分析

莫扎特是18世纪奥地利古典乐派的重要作曲家代表之一。追溯其一生，我们可以发现，他一直潜心致力于音乐创作的发展与提升，他的创作灵感源源不断，是一位全方位的作曲家。我自从接触莫扎特的声乐作品以来，被他极其优美的旋律与典雅的歌词所吸引。他在作曲时常以歌者的音色与技巧为依据，为其量身定制。这部作品是一种所谓世俗倾向的教堂音乐，把歌剧与协奏曲这两种音乐形式完美结合在一起，其快—慢—快的乐章组合，具有当时歌剧序曲或声乐协奏曲的特色。这部作品风格华丽流畅，并使用了大量的花腔乐句，它属于介乎宗教与世俗之间的作品，以当时意大利世俗化教会风格为范本，除了拉丁文歌词与管风琴的数字低音外，几乎听不到宗教的音响。

### 2.1.1 旋律的发展特征

这部作品一共有三个乐章，每个乐章的主题也不尽相同。这些主题控制着音乐的发展，使得乐曲的音乐素材高度集中，由此可见作

曲家的创作能力。同时,从主题的发展与变化中,我们还能窥探出作曲家的创作技法。

2.1.1.1 第一乐章《欢腾喜悦》的主题发展

在第一乐章中,作曲家一共使用了三个主题,一开始由中提琴演奏的主题,在乐队齐奏的衬托下显得华丽而又辉煌。首先是从主音到属音的下四度跳进,随后是音阶的上行,这里使用了一个降七级的外音♭E,随后落在了下中音D上。旋律的发展呈拱形,同时和声进入了下属方向。为了进一步发展旋律,作曲家使用了一个六度的大跳,并一直强调重复。在下行五度跳进后,旋律依旧是拱形发展,只不过前面是音阶上行,后面是分解和弦。最后主题经过环绕停在属音上。

**谱例 1** Exsultate Jubilate

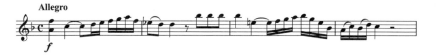

这里的旋律发展十分有趣,且具有鲜明的个性。旋律中不断的大跳音程正好呼应了乐曲曲名中的欢呼雀跃。拱形的旋律线条发展使得乐曲跌宕起伏,犹如流水般不断向前。而这里作曲家并没有使用太多和弦,一共只用了主和弦、下属和弦和属和弦这三个和弦来确定调性。为了进一步强调与巩固调性,作曲家在前两节都运用了主持续音,使得调性感更明确,属和弦运用了转位到原位和弦,其他的和弦都只运用了原位和弦。

第一乐章的第一主题并没有出现在人声声部,而是始终出现在伴奏声部中。由两支双簧管以快速的十六分音符随后连接向上跳跃的八分音符,使得乐曲一直持续在欢快、热闹的情绪氛围中。在独唱重新呈示过第一主题后,第二主题移至属调进行伴奏,这时乐曲的第三主题在人声声部出现。这里的旋律的构成音是C大调音阶的所有音,听众却完全无法感觉。作曲家让旋律首先由主音下行到属音并且重复,最后进行了七度大跳,最后下行到主音。

**谱例 2** *Exsultate Jubilate*

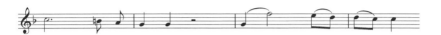

这里第二呈示副部主题的开始,作曲家在这里连续使用了 $K_4^6$ 和弦,使得乐曲的终止感在这里得到体现。乐曲的旋律进行了重复,以加强效果。接下来人声的旋律是快速、持续的十六分音符,歌者在这里需要保持好气息,不能中断旋律,需要一气呵成。

2.1.1.2 第二乐章《加冕的圣母玛利亚》的主题发展

第二乐章既不是属调,也不是下属调,而是运用了三度关系的 A 大调,强调小二度进行的第一主题与平行下行的第二主题都是歌谣风味十足的旋律。

**谱例 3** *Tu Virginum Corona*

第一主题由主音向上五度跳进到属音,最后下行至上主音 B 后又再次迂回上行,#C 与 D 是小二度音程。最后三度与四度音程的加入使得旋律更加跳跃,但在最后还是使用了小二度音程。与第一主题相同的是,第二主题也使用了音阶下行的作曲手段,但不同点在于,第二主题并没有使用迂回的旋律发展,而是在落音处反向,第一次是三度,第二次是五度。

2.1.1.3 第三乐章《阿利路亚》的主题发展

第三乐章经常被歌唱家在音乐会中独立演唱,在第三乐章中,母音(啊)一直被持续使用。同时,在伴奏声部中,断奏的使用更贴切歌词中的"跳吧,欢喜吧"的语境。

**谱例 4** *Alleluja*

快速的三度双音体现了乐曲欢快的氛围。乐曲从主和弦的五音开始,然后停在属五六和弦上。随后,作曲家运用了典型的功能和声逻辑Ⅰ—(Ⅵ)—Ⅳ—Ⅴ—Ⅰ,使得乐曲的风格明确。因为断奏的运用使得原本明朗欢快的曲调更加华丽轻快。

### 2.1.2 和声手法运用

大、小调功能体系即大小调体系和声,或称调性和声、功能和声,也有人称之为传统和声或古典和声等。萌芽于中世纪、文艺复兴时期,形成于巴洛克时期,成熟于古典主义时期。在浪漫主义时期,大、小调体系的和声得到了进一步的完善。《欢腾喜悦》这部作品正是大、小调体系和声的代表作品。

大、小调功能体系由特定和弦与调式音列组成。大、小调功能体系调性的建立,无论是否局限于一定的调式音列(只用自然音体系或加入变化音体系),都不影响调性的建立。大、小调功能体系虽然与调式音列有关,但主要还是以主音及其衍生的主和弦(大、小三和弦)为中心,以四、五度关系为基础。

大、小调功能体系有多种特点,分为以下几个方面。一是在纵向上以三度结构的和弦为基础,尤其是三和弦、七和弦。以协和的大三和弦或小三和弦为中心,中心一般都是固定的、唯一的。二是以自然大调、和声小调的调式音列为基础,其他调式音列起到辅助使用大、小调体系。三是音与和弦以不同功能分为不同等级,其关系的划分以四、五度关系为基础,处于控制主导地位;以二、三度关系为辅,处于依附地位。

#### 2.1.2.1 和弦结构

在《欢腾喜悦》中,作曲家全部使用了三度叠置的和弦结构,运用

了古典和声体系中的大三和弦、小三和弦、大小七和弦等常用的和弦结构。在和弦的选择上，也主要使用了主和弦、下属和弦、属和弦等常用的和弦。为了让作品听起来更加悦耳，作曲家在作品中使用了大量的和弦外音，这些外音包括了自然音体系与半音体系的助音和经过音、留音、先现音和倚音等。外音的使用让作品中的不协和的因素增加，使得作品不断在矛盾与冲突、紧张与和谐中得到发展。

2.1.2.2 调式与调性

乐曲除了宣叙调《白日闪烁出亮光》只运用了单一调性 D 大调外，其他三个乐章都进行了转调。在第一乐章的再现部分，为了使得乐曲回到主调上来，形成"调性回归"，主部由属调 C 大调进入为"假再现"之后回到"真再现"F 大调进行陈述。在乐曲的第 84 小节开始，乐曲并没有回归到 F 大调，而是由 F 大调的下属调 ♭B 大调进入，在副部主题结束时才回到主调 F 大调，同样具有"假再现"的意义。之后，乐曲彻底地回到主调 F 大调进行陈述。由此可见，作曲家除了运用主调，还使用了属调与下属调。

第二乐章同样如此，作曲家由主调 A 大调开始，随后转入了属调 E 大调，在回到 A 大调之后又转入了下属调 D 大调。值得注意的是，作曲家在第二乐章的结尾处运用了同主音大小调的交替，降低了主和弦的三音，得到了 A 大调的同主音小调的主和弦 a 小三和弦。通过共同和弦转调，进入了 a 小调的一级关系调 F 大调，开启了第三乐章。

第三乐章只运用了主调 F 大调和属调 C 大调。在第一插部中，25 小节的伴奏声部运用了主调 F 大调和属调 C 大调的共同和弦转调，使乐曲在进入第一插部时顺利转到属调 C 大调，并进行发展。在第二主部中，作曲家还运用了离调手法，使得旋律与织体的半音化程度加强。之后很快回到了属调 C 大调之上。在乐曲的最后，低音声部持续的强调重复主调的主音 F。主音的不断巩固与重复加强了调性，并为下一个主部的再现提供了良好的基础。

2.1.2.3 和声节奏与织体

作品的整体和声布局基本上是一个小节使用一个和弦，音乐进

行的速度较快,所以产生了和声节奏较快的效果。

**谱例 5** Exsultate Jubilate

谱例 5 是乐曲第一乐章开始的四个小节,作曲家只使用了主和弦、下属和弦与属和弦这三个和弦。为了低音更加稳定,同时强调调性,作曲家在前两小节使用了主持续音。这种持续音的手法在这部作品中得到了广泛的运用,其目的就是对主音的加强。这里的和弦功能逻辑是主—下属—属—主,一开始就明确了调性。需要注意的是,作曲家在运用属和弦时,一开始使用的是属三四和弦,然后才是属七和弦。这样做的目的是低音声部的二度进行。这样不仅增加了低音的旋律性,同时打破了低音只有主音和属音的单调情形。

作品的和声织体主要采用了和弦式,基本上都是四个声部。通过分析可以看出,其实际上是由两个声部与两个声部相结合的结构形态,四个声部结合成了完整的和弦,并进行协调发展。

2.1.2.4 和声语汇

在和声语汇方面,作品主要使用了正格进行(Ⅰ—Ⅴ),变格进行(Ⅰ—Ⅳ)和阻碍进行(Ⅴ—Ⅵ)等,符合古典和声的功能进行逻辑。只是有时候,作曲家会使用二级和弦去替代下属和弦。

另一个有特点的和声语汇就是离调的运用。乐曲较常使用的有重属和弦,其经常使用在终止四六和弦之前,有时候也独立使用,随

后解决到属和弦。例如,在第一乐章的第 27 小节,为了配合旋律中的降七级音,作曲家使用了四级和弦的离调。在随后的第 44 小节中,又使用了二级和弦的离调。离调和弦在整部作品中的运用并不多,但它们却具有画龙点睛的作用。正是这些和弦的使用,使得作品的半音化与不协和程度提高,达到了戏剧冲突的目的。

除了离调和弦以外,另一个重要的和声语汇就是持续音的使用。在运用持续音时,主要使用主音持续音和属音持续音这两种。而在这部作品中,主持续音的使用随处可见,而属持续音只在第三乐章中使用。在乐曲的第 102 小节开始,为了增加终止感,这里的和弦全部使用了属七和弦解决到主和弦,而低音声部的属持续音的使用使得乐曲的结束感不断增强。

《欢腾喜悦》以清亮的和声音响、精致的和声织体、简洁的和声节奏、朴素而高雅的和声语汇、适度的对比构筑了莫扎特和声风格典雅的特点。莫扎特的和声风格体现了古典时代的理性审美原则,强调理性对创作的指导作用,坚持一切艺术形式都必须符合优雅的审美要求。研究莫扎特的和声有助于我们更好地了解莫扎特音乐的整体风格和古典音乐的整体特征,具有一定的研究价值。

## 2.2 《欢腾喜悦》曲式结构研究

在莫扎特的音乐时期,几乎所有音乐曲式结构的基础都具有"奏鸣曲原则"。它制约着单个乐章的设计,但是并不牵扯作品的整体。通常在这一类的作品中,当主部主题完成后,音乐会从其主调转至其他的调,通常在大调中转向属调,而在小调中则转向关系大调。而后会出现副部主题材料,这些音乐材料的全部或大部分很可能之后会在乐章中再现,音乐之后会回到主调,这样的目的是使得音乐在不同调上进行陈述,从而在结构上产生紧张感。《欢腾喜悦》全曲采用拉丁文歌词,创作本意是赞美耶稣的降生。作品的创作周期只有 3 周,展现了莫扎特高超的创作技巧和速度。

这部作品是一部小型的声乐与乐队协奏曲,共包含三个咏叹调

和一个宣叙调。这些乐章之间既有联系又有对比，形成了一个完整而富有变化的音乐结构。莫扎特在这部作品中创造了不同的音乐气氛，如轻松欢快、庄严肃穆、温柔甜美、热烈激昂等。四部分音乐风格有所差别，但整体不可分割。作品的诗意导向性很明确，从现实景象逐步转变为对主的赞美。特别是最后一首《阿利路亚》，整部分的歌词只有"阿利路亚"，分节歌式的结构层层递进，对主的赞美表达得淋漓尽致。作品的乐曲结构基本遵循了古典时期的乐曲结构原则，第一乐章《你们欢呼雀跃吧》采用了双呈示部构成的小奏鸣曲式，即没有展开部的双呈示部奏鸣曲式。第二乐章《加冕的圣母玛利亚》采用了无展开部的双呈示部的奏鸣曲式。第三乐章《阿利路亚》的曲式结构为回旋曲式，以下将做具体分析。

## 2.2.1 第一乐章《欢腾喜悦》曲式结构分析

乐曲第一乐章的曲式结构是由双呈示部构成的小奏鸣曲式，即没有展开部的双呈示部奏鸣曲式。在以快板为速度的第一乐章中，莫扎特使用了典型的意大利器乐协奏曲的结构，而这种快板的双呈示部结构通常被用于古典主义时期协奏曲的第一乐章。乐曲的主题非常简短、精彩，乐队由强力度奏出主音下行跳进到属音，随后音阶上行，非常精彩，具有协奏曲的风格。通常在协奏曲中，第一呈示部是由乐队奏出，第二呈示部则由独奏乐器演奏，其不仅能加深听众对于旋律的印象，同时也使乐曲的主题得以升华。

第一乐章共有 129 个小节，结构包括了双呈示部、再现部及尾声，调性为 F 大调。乐曲的曲式结构图见表 1。

表 1 《欢腾喜悦》第一乐章曲式结构

| 第一呈示部 | 第二呈示部 | 再现部 | 尾声 |
| --- | --- | --- | --- |
| 1—20 小节 | 21—70 小节 | 71—120 小节 | 120—129 小节 |
| F | F—C | C—♭B—F | F |

从曲式结构图我们看出，莫扎特在很大程度上模仿了当时意大利歌剧序曲的结构，省略了展开部。而在音乐风格上，这部作品既体现了莫扎特对古典主义音乐形式和风格的掌握和发展，又显示了他对不同音乐流派和风格的吸收和融合。他在这部作品中运用了各种装饰音、变奏、模进、对位等手法，使他的旋律既优美流畅，又富有表现力和想象力。

歌曲的结构很大程度上与歌词相关联，宏观而言，整体由两大部分构成。就结构原则而言，近似于带有双副部的奏鸣曲式结构，且无展开部。呈示部为"朴实"的叙述，再现部为同样的歌词内容。就音乐处理方面表现为：调性的转换、旋律形态的走向发生变化以及重要音节"加花"延长，这一切都是为了充分表达歌词内容。

乐曲的第一呈示部是乐队的齐奏，作品在 F 大调上进行发展陈述，乐曲结构由主部主题（1—7 小节）、连接部（8—10 小节）、副部主题（11—18 小节）和结束部（19—20 小节）构成。乐队的陈述为整首曲子奠定了基本的音乐风格，调性较为鲜明，F 大调上进行陈述，前十小节以弦乐为主体的混合音色，落点为柱式和弦结构半终止属和弦；第 11 到 20 小节为第二部分，此处音色以弦乐队与双簧管的音色交替为主要手法，风格与前截然不同，最后落于主和弦。整个片段的风格轻快明朗，同时乐曲中较常使用跳跃性的节奏，使得作品呈现出莫扎特流畅的音乐特点。值得我们注意的是，作曲家在伴奏声部使用了八度的震音以及快速的十六分音符的同音反复，也体现了标题"欢呼雀跃"的性格特征。

第二呈示部是由独唱演员完成的部分，在这个乐章中具有重要的地位，可以分为主部主题（21—33 小节）、连接部（34—47 小节）和副部主题（48—70 小节）三个部分。人声的加入好像是一位智者出现一般，使原本热情活跃的音乐引入流畅庄严的人声，但是并没有使音乐显得压抑，反而展现出明亮华丽、高贵典雅的音乐风格。① 歌词大意为"欢腾喜悦，哦，有福的灵魂"，结构为 6+7 两个句子。前 6 小

---

① 宫珍珍《探究莫扎特宗教声乐套曲〈你们欢呼雀跃吧〉（K.165）》，天津音乐学院 2019 年硕士学位论文，第 6 页。

节旋律的进入形态以跳进为主且逐步趋于级进形态,整体较为"平淡";后 7 小节的乐句,开始极为低沉且在临时下属关系调 ♭B 大调进入,似乎是一种"欲扬先抑"的手法;之后回到原调且音区较高,音符变为八分音符,尾部再次强调"兴高采烈地欢呼雀跃"。之所以说这是一个完整的段落,是因为 32 到 33 小节出现了 F 大调完满全终止。之后 34、35 两小节采用第一呈示部(19—20 小节)的材料片段,既是对主部的补充同时形成到副部的过渡。

连接部是一个(4+4+4)三乐句构成的乐段,调性布局为 F—C—C,第 47 小节落于 C 大调的属和弦。就音乐结构意义而言,这是一个开放结构乐段;就音乐表现内容而言,这意味着下一段落将会对 B 段落所述歌词内容进一步做音乐上的表现。歌词大意(以逗号为分句点)为"唱着甜美的歌,唱着你的歌,诸天与我一起歌颂",这里出现了一种特殊的歌词与乐句相对不一致的现象,或者说将歌词进行拆分开是为了符合音乐结构的需要,也可以说这样的歌词处理意在使每一句歌词显得"意犹未尽",使演唱者更加注重音乐的连贯性。这里的音乐形象体现了宗教音乐的特点,同时还呈现出世俗音乐与宗教音乐的融合。乐曲在这个片段进行了转调,从 F 大调转入了属方向的 C 大调,使得欢乐的乐曲特征增添了抒情性。

副部的主题歌词与之前相同,但音乐性质发生变化。主部为主调音乐,局部复调因素与之相呼应,而副部则主要采用复调技法。第 48 小节采用第一呈示部第二小部分的音乐材料,具有一定的诙谐效果,这样看来,旋律似乎是乐队部分的对比复调,演唱者应该特别注意对乐队部分的聆听。就结构而言,这一段落为(4+14)的非对称结构乐段,整体调性为 C 大调。第二句重复第一句歌词,并于第 56 小节的尾音"E"采用"花唱式"手法延长四小节后,继续拓展音区。通过加入大跳音程,在第 60—65 小节达到全曲第一次高潮阶段,并继续由乐队持续几小节。高潮区形成后,音乐逐渐趋于平缓,到达再现部分。

由于这个乐章没有展开部,所以出现的就不是传统意义上的再现部,它出现的目的是使得乐曲回到主调上来,形成"调性回归"。再现部分与呈示部分相比较,主部由属调 C 大调进入为"假再现"之后

回到"真再现"F上进行陈述,在乐曲的第84小节开始,乐曲并没有回归到主调F大调,而是由F大调的下属调♭B大调进入,在副部主题结束时才回到主调F大调,同样具有假再现意义。之后乐曲彻底回到主调F大调进行陈述,这些特点都体现了奏鸣原则(调性回归)构建的曲式结构。除了调性的变化外,局部音高材料发生变化,曲式结构并无变化,依然为(6+7)的乐段结构,之后两小节的补充同时起到过渡的作用。在这个部分,结构与之前发生"畸形"变化,呈示部分(4+4+4)变为(4+4+14)结构。莫扎特将前面的"花唱式"创作手法用于这里,前面"花唱式"为4小节,这里扩充长达9小节,"E"这一音节的夸张性装饰极大地丰富了音乐的表现力,使旋律更富有生命力。音高的准确性、声音位置的统一性、微观呼吸的控制等元素,对演唱者也会有一定的挑战。之后乐曲整体调性回归到F大调,体现了奏鸣原则。乐句相对之前似乎有所"收敛",第二句减少"花唱式"的音符,最后在第119小节落于主音。经过两小节的乐队铺垫,第122小节最后一次咏唱"在太空吟诵赞美诗"。

乐曲最后的19小节的尾声,在作品的123小节处出现了一个华彩乐队,这里莫扎特给歌者预留了发挥的空间。整个华彩片段出现在终止四六和弦之后,当歌者演唱完华彩片段之后,整个乐章就迎来了终结。这一部分与第一呈示部遥相呼应,收束全曲。

第一乐章的整体风格可以用华丽来形容,典雅庄重的人声声部与欢乐跳跃的伴奏声部相得益彰,二者的结合并没有显得突兀,而是非常和谐。这里体现了莫扎特音乐创作中宗教音乐与世俗音乐的融合。

### 2.2.2 宣叙调《白日闪烁出亮光》曲式结构分析

咏叹调除对歌词内容的表现外,更注重旋律线条的表现力;而宣叙调更加注重语言自身音节(音调)的韵律感,或可说是以一种"吟诵"的方式进行陈述。就音乐织体形态而言,咏叹调的织体更加丰富多变,与旋律的韵律紧密相关;宣叙调则通常采用最简单的柱式和弦的和声背景给予演唱者一定的底色支持。

宣叙调《白日闪烁出亮光》是作曲家为了链接第一乐章与第二乐章的，由管风琴进行伴奏，调性为 D 大调。在宣叙调中，音乐的旋律性会让位于歌者的朗诵性，这是因为在这样的片段中，听众需要清楚地听到歌词，同时突出歌词的表达内容，使得音乐中的戏剧性冲突增强。这里要求演唱者在熟悉歌词的同时，还要用虔诚的语气进行演唱，仿佛在向上帝祷告一般。正因如此，这个片段的音乐风格与第一乐章形成鲜明的对比，同时也为引出慢板乐章进行了铺垫。

这首乐曲共 12 小节，其音乐本质形态可谓一气呵成。局部由于语言自身韵律（重音的位置）的需要，节奏时紧时松。内部在Ⅳ、Ⅱ和弦上产生的临时调性使得音乐色彩较为丰富。第一小节的旋律形态为分解和弦，似乎是一种坚定信念的表现，特别是纯五度的下行跳进，符合泛音列中临时一种属（Ⅴ）到主（Ⅰ）的自然吸附力。这要求演唱者在演唱时要表达出音的自然倾向性，气息需要极其统一，毫无痕迹地过渡。第 1 至第 2 小节的连接为二度级进上行音阶，与之前的跳进相比，更加平缓，表现出声音技巧的暂时放松，实际上需要更加注意音准的表现。这样便形成一种跳进与级进相结合的旋律形态，之后整首曲子一致沿用这样的形态，使得演唱者情绪处于不断变化之中。

### 2.2.3 第二乐章《加冕的圣母玛利亚》曲式结构分析

整个西方音乐的发展都离不开宗教的影响，此首乐曲主要大意为"你圣母的花环，赐予我们和平，消除我们内心的悲伤，我们打心底叹服"。这既是对圣母的祈祷，也是一种深情歌颂。与第一首歌曲的相似之处在于这首乐曲同样有较长的乐队前奏，已经出现歌唱部分的旋律。乐队方面仅有弦乐队与自然圆号参与，无木管组，似乎是少了一定的趣味性，却与标题所示音乐形象一致。结构方面，整体带有奏鸣原则，但并不完全是奏鸣曲式结构。第一大部分由两个段落构成，第一次是对歌词的基本表述，没有太多的力度变化；第二次结构进行延伸（衍生），后半部分的歌词特别强调了局部语气音节。第二大部分同样由两个部分构成，第一次同前类似，音调更为平缓，情绪更加饱满；第二次的后半句除了做一定的延伸（衍生）外，整句再一次进行陈述，与第一

大部分形成一定的对比,旨在"夸张"性地表达对圣母玛利亚的赞美。

第二乐章为慢板节奏,全曲共有 115 小节,调性为 A 大调,曲式结构为无展开部的双呈示奏鸣曲式,由第一呈示部、第二呈示部、再现部及尾声构成。这个乐章与第一乐章的对比主要体现在速度方面。整个乐章的旋律抒情婉转,与上一个乐段的宣叙调形成链接,同样也需要以祈祷的语气进行演唱。乐曲的曲式结构图见表 2。

表 2 《欢腾喜悦》第二乐章曲式结构

| 第一呈示部 | 第二呈示部 | 再 现 部 | 尾 声 |
| --- | --- | --- | --- |
| 1—22 小节 | 23—66 小节 | 67—101 小节 | 102—115 小节 |
| A | A—E | A—D—A | A |

从曲式结构图可以看出,作曲家运用了与第一乐章相同的曲式结构,即缺少展开部的双呈示部的奏鸣曲式。

在第一呈示部中,也是由乐曲进行演奏,音乐在 A 大调上显现,并没有明显的对比因素,整个片段呈现出安静而庄重的音乐风格。音色以弦乐组为主体,局部穿插自然圆号,结构为(4+4+4+6)四个句子构成。第一句预示着歌唱部分主题的音调,音区位于中音区;第二句出现"呼应式"微观动机进行陈述,音区高于第一句,带有一定的转折意义;第三句由带有"鼻音"的大提琴进行演奏,音乐较为深沉,织体出现后十六分音符的补充律动手法,深沉中带有一丝流畅;第四句旋律由小提琴演奏,节奏出现同步律动的和声性表现手法,体现出庄严、神圣的气氛。对于演唱者而言,深入了解乐队的表现力才能更准确地诠释作品。

第二呈示部是由独唱开始,这与第一乐章相同,不同之处在于调性的区别。这里依旧是由 A 大调开始,在第 33 小节处转入了属调 E 大调,而在第 40 小节处引出了副部主题。第一乐句上行跳进音程行进之后变为级进关系,每一微观结构的尾与首皆为同度或者二度关系,没有太大的起伏,显得庄严而神圣。第二句重复第一乐句材料之

后有些许变化,尾部呈开放终止,落于 A 大调的属和弦上,这就要求演唱者对音乐的处理不可出现断层。同时,这一和弦成为后一片段的主和弦,两段之间的过渡会更加自然。

第二呈示部中的副部虽然使用了同样的歌词,但音乐却与主部形成对比。第一乐句为 6 小节,相对于主部的第一乐句无变化,但调性发生变化,转入 E 大调上进行陈述,且旋律形态发生变化,跳进音程增多,整体音区上移,音乐张力值增加,更具表现力。第二乐句进入后,调性依然为 E 大调,整体音区继续上移且织体发生变化,后十六分音符的点缀使得音乐更富有活力,长度扩展为 14 小节,与第一首咏叹调手法近似,但并无"夸张"的"花唱"进入,这是为了不破坏标题所述内容。如果以朗诵的一般方式来理解,将会更加到位。诗体的朗诵,通常将中间具有语气式的词进行重复,甚至是局部重要的动名词形态继续重复,意在充分表达诗体隐含的深意。之后的连接部(第 54—60 小节)具有过渡的意义。结束部乐句的构成材料与开始部分相比较,具有倒装再现的意义,第二乐句与前面部分的第二句一致。乐句由属和弦进入,具有一定的不稳定性,在一种"疑问"式的语气下,第二乐句彻底回归初始阶段的旋律形态。

再现部的调性回到主调 A 大调,这里乐曲的主题完全是呈示部主题的再现。但是主题呈现完后,音乐迅速转入了下属调 D 大调,调性色彩偏向暗淡。七度旋律音程的加入,首先将音乐张力提升到一定的高度,音乐情绪高涨。随后隐伏声部逐步下行,落于半终止属和弦,形成临时的稳定。第二乐句采用类似呈示阶段的表现手法,重复重要语气词以及重要谓宾结构,特别是第 85 小节声乐部分的第一次音区到达 a2 高音区,且在高音区持续,这对演唱者来说难度颇大。第三乐句扩展为 17 小节,歌词与第二乐句相同,音乐结构较开始部分进一步延长,旨在体现前文提及的"夸张性"表达。需要注意的是,副部主题的开头也是对第一呈示部进行了再现,这时并没有完成再现,只是对之前的节奏进行了再现。

这个乐章的结尾与第一乐章一样,都有一个华丽的华彩片段,虽然这个华彩片段只有 2 小节,但已经足够歌者展示。华彩之后的 10 小节

音乐片段不仅起到终止这个乐章的作用,同时也引出了第三乐章《阿利路亚》。这个片段的音乐素材与主部主题形成了首尾呼应,使得乐章的结构得到了平衡。最后乐曲停在了 F 大调的属七和弦上,使音乐非常自然地进入了下一乐章,使得乐章之间的断裂感不复存在。

### 2.2.4 第三乐章《阿利路亚》曲式结构分析

阿利路亚是来自《旧约诗篇》的第一句,是希伯来语对上帝的赞美词。本首咏叹调全曲仅围绕"阿利路亚"一词呈示并逐步展开,对于作曲家来说,增加了创作难度;对于演唱者来说,对乐曲结构的精准分析直接关系到能否错落有致地表现音乐的不同层次。本首乐曲的曲式结构偏向于回旋曲式。

这个乐章是整部作品最著名的一个乐章,在声乐发展史上占据着重要地位。其音乐情感既体现了莫扎特对宗教主题的虔诚和敬仰,又表达了他对生活和艺术的热爱和欢乐。很多花腔女高音将这部作品作为自己音乐会的压轴曲目。乐曲共有 159 个小节,通常会与上一乐章进行不间断演奏,在速度上形成鲜明对比,就像人们在教堂祈祷后的狂欢节,这也与主题《欢腾喜悦》十分契合,也将全曲的情感推向了顶峰。乐曲的曲式结构图如表 3。

**表 3 《欢腾喜悦》第三乐章曲式结构**

| 引 子 | 第一主部 A | 第一插部 B | 第二主部 A′ |
|---|---|---|---|
| 1—8 小节 | 9—24 小节 | 25—59 小节 | 60—85 小节 |
| F |  | C | C—F—C |
| 第二插部 C | 连接部 | 第三主部 A″ | 尾声 |
| 86—118 小节 | 119—126 小节 | 127—154 小节 | 155—159 小节 |
| C—F | F |  |  |

8个小节的引子由乐队来演奏,两个呼应式句子构成整首乐曲的核心主题,渐进式旋律使得音乐流畅而甜美,刻画出对耶稣的赞美之情。调性也回归到第一乐章的主调 F 大调。

第一主部 A 为人声演唱部分,由两个长乐句构成,每个长乐句包含两个较短的乐句构成复乐段结构。其材料承接前奏,意在强调主题音调。其中第二长乐句后半部分有局部变化,加入下属调性的临时调性并意外解决,与第一长乐句形成对比。演唱者注意音乐情绪稍作起伏之后归于平稳。

第一插部 B 进入了属调 C 大调,与呈示性段落 A 在长度方面形成极其不平衡的对比,并具有展开意义。具体结构由四部分构成。第 25—32 小节是材料的呈示,旋律形态出现跳进式的不协和音程,织体形态变为八分节奏律动的分解和弦,和声为主属不间断的交替进行,最后落于开放式终止属和弦。即使如此,短的 8 小节依然与 A 段落形成对比。33—40 小节,与第一部分相比,更具有展开意义,具体体现为:第 33 小节的音乐材料源于第 25 小节,乐队织体形态出现隐伏声部为二度进行的十六分音符快速律动,情绪进一步高涨。紧接着第 37 小节歌唱进入,并出现完满性的全终止。第 41—48 小节,这是对比前一部分的重复,旨在强调上一乐句的音乐性格,并预示着下一部分将会产生一定的变化。从音乐处理角度来看,这一小节在力度方面比上一乐句有一定的下降,这样同质性乐句重复时"人为"地形成一定对比。第 49—59 小节,整体 B 段落的高潮部分,开始调性临时回到主调 F 大调,尾部回到 C 大调并全终止。旋律形态方面主要体现在"花唱式"的加入,并有八度的跳进,音乐张力值急速增长,进一步增加音乐表现力。

第二主部 A′ 是第一次主部主题的再现,但并不是完全再现,原本人声演唱的部分被乐队伴奏取代,形成局部呼应手法,形成了乐队与人声交替的问答形式。第二句的演唱部分经过夸张性扩充变化,先是"花唱式",装饰"阿利路亚"的"亚",旋律之后,逐步转入高音区,快速十六分音符节奏形态转变为持续的四分音符,坚定铿锵有力。这里调性依旧在 C 大调上进行发展,而并未回归主调 F 大调,因

此这个片段并没有结束的感觉。

第二插部 C 的歌词非常简单,整个部分只有一个"a"字。这部分由乐队继续推进演唱,这是咏叹调惯用手法,使用乐队继续延长演唱者的高潮阶段,避免"戛然而止",进一步释放音乐本质性的张力。虽然只有一个字,但包含了歌者对于上帝的虔诚之心。随后乐曲调性回归到主调 F 大调。

之后的连接部虽然只有短短的 8 小节,但起到了承上启下的作用。在调性上虽然已经进入主调,但是这里并没有完成终止,这个部分在曲式结构中被称为"假再现"。

第三主部 A″与第一主部 A 段落结构完全一致,是真正的再现部分。不同的是,第一个长乐句是乐队先行进入,之后 4 小节歌唱进入;第二个长乐句完全由乐队接管,整体音区更宽,那么歌唱部分的临时"撤掉"旨在为了最后一次彻底释放对耶稣的赞美。随后的片段音区较前一段落较高,形成对比,但没有更夸张的变化。后一乐句的同质性材料进入之后,从第 147 小节变为一音节一小节的律动,音高起伏度较大,可以说完全释放对耶稣的赞美之情。

全曲的尾声只有 5 个小节,这里是主调和弦的多次重复,延续前段演唱部分"意犹未尽"之感,用完全重复的主和弦进行收尾。

通常宗教歌曲的特点都是缓慢且悠长的。莫扎特在这部作品中将宗教音乐与世俗音乐相结合,用欢快明朗的音乐语言表达了对上帝的忠诚、虔诚。

## 2.3 莫扎特的创作技法特征

莫扎特作为古典主义流派的重要作曲家,他的音乐风格朴素却不失华丽,其创作领域体裁较广,包括交响乐、室内乐以及歌剧等,在整个西方音乐史上占据重要地位。他的音乐旋律优美且富有戏剧性;声部之间的复调因素交织复杂;和声虽属功能性和声体系,但和声节奏变化使其音乐极具色彩性;乐队音色极为巧妙,与所塑造的形象融为一体。就声乐作品(也包含以声乐为主、带有乐队的声乐作

品)而言,宗教圣乐独唱曲显得尤为重要。

作为古典主义音乐的典范,莫扎特在欧洲音乐的发展过程中起到了巨大作用。莫扎特一生共创作了 22 部歌剧、49 部交响乐、42 部协奏曲、1 部安魂曲以及数百部奏鸣曲、室内乐、宗教音乐和歌曲等作品。歌剧是莫扎特创作的主流,他与格鲁克、瓦格纳和威尔第并称为欧洲歌剧史上四大巨子。在交响乐领域,他与贝多芬、海顿一起,为欧洲音乐史作出了巨大贡献,写下了最光辉的一页。莫扎特也是钢琴协奏曲的奠基人,他对于欧洲器乐协奏曲的发展同样作出了杰出贡献。除此之外,他的《安魂曲》也是宗教音乐中不可多得的杰作。莫扎特是 18 世纪末的欧洲作曲家,他的音乐极大地体现了时代精神尤其是公民社会的思想他的歌剧对当时来说极具进步的意义。他的音乐具有歌唱性,但也蕴藏着深深的悲伤,反映了莫扎特时代知识分子的命运。

### 2.3.1 打破常规不拘泥于传统形式

18 世纪的欧洲是巨大的文化熔炉,各方面都得到了不小的提升。随着贵族阶级的兴起,古典乐派发展到了一个高峰。商业、技术、交通的进步,人们思想的启蒙,以及对人性解放的追求,都影响了莫扎特的生活,使得莫扎特的思想观念以及创作风格都受到了很大的影响。这一时期,器乐逐渐取代宗教歌唱成为主流。在体裁上,不再局限于宗教与圣经,自然、历史、人物、事件逐渐成为流行的创作元素。在莫扎特的音乐中,我们可以感受人类的感情与自然之美,它是那么的纯粹、干净、不含有任何杂质。他认为善与恶是对立的,爱、和平与正义是世人所向往并为之奋斗的。在这个日益开放的时代,这些人以新的思想挑战教会和封建社会的严格统治,形成了一种对立的局面。莫扎特也以他自己的方式,通过他的音乐反映这些情感。他与教会中虚伪的信徒几乎没有接触,他追随自己内心的呼唤,进行自由的作曲。18 世纪末和 19 世纪初期,基督教内部非传统教派的力量激增,将赞美诗提升到与教堂礼拜音乐同等的地位。在当时天主教国家中,反宗教改革运动的政治力量和宗教正统意识的增强导致

了两者之间关于神圣音乐的实际和观念上的争论。尽管莫扎特在歌剧和器乐方面的声誉越来越高，但他也卷入了越来越激烈的争论。一般来说，宗教音乐很难掌握，但莫扎特创作的这部宗教作品不再严格遵循过去的传统技法，而是结合了当时逐渐流行的世俗音乐元素。

莫扎特一生创作了600部音乐作品，其中宗教音乐占他全部作品的1/3，如9部康塔塔、17部教堂奏鸣曲、20部弥撒曲等。这很好地体现出了他对宗教音乐的贡献。他所创作的宗教音乐并没有只继承传统，而是通过不断探索形成了属于自己的创作风格。就他的声乐作品而言，莫扎特并不希望自己的作品像传统教堂音乐那样死板、难以理解。他将简单易懂的文字与优美壮丽的音乐和清晰的音乐质感结合在一起，形成了独特的宗教音乐风格。有人曾经说过，莫扎特的宗教音乐完全可以与世俗歌曲甚至是歌剧中的咏叹调相媲美。最典型的便是《欢腾喜悦》。

《欢腾喜悦》是一部融合了巴洛克时期歌剧咏叹调中利都奈罗元素与奏鸣曲形式融合的作品，大胆创新，音乐旋律优美流畅，和声织体清晰明了，歌词简洁明快、切中要害，歌曲旋律线条清晰，充满张力，这是它与许多其他宗教作品的区别。《欢腾喜悦》一般作为经文歌为人们所认知。经文歌起源于12世纪二声部的奥尔加农，13世纪初，没有歌词的克劳苏拉的上声部被人们添加上了歌词，逐渐产生了这种经文歌的样式。最初的经文歌只给一个上声部或两个上声部配拉丁语歌词，后来到了13世纪中叶，法语歌词逐步出现，作曲家们也开始重视二重和三重的经文歌形式。音乐形式趋于自由，并在后期逐渐融入世俗元素。17世纪，经文歌流派失去了往日的稳定性，许多作曲家开始将经文歌的作品与协奏曲、咏叹调等混合在一起，《欢腾喜悦》则可以作为这种"混合物"的代表作品。其曲式结构融合了声乐和器乐协奏曲的风格。作为维也纳古典音乐流派的领军人物，莫扎特的作品具有古典音乐流派的典型特征。《欢腾喜悦》是莫扎特创作生涯中期的一部歌剧，在启蒙运动的影响下，作品《欢腾喜悦》将早期受到威尼斯乐派影响的华丽风格与情感感情的自然回归完美地融合在一起。《欢腾喜悦》使用了大量的长乐句，音乐线条清晰明快，

以和声性伴奏声部衬托上声部主旋律,由二至四小节为单位构成音乐结构。

作品中使用了大量的装饰音,使旋律更优美,更有趣味性,使音符与音符之间的连接更加生动、动听。根据音乐史的记载,早期演唱格列高利圣咏的歌唱家常在乐曲原有旋律的基础上,加入装饰音去演唱。16 世纪的演奏家也常常在乐曲本身没有装饰音的情况下,自己加上一些短时值的音符,变成即兴演奏(自由装饰)。当时的演奏者,几乎没有完全按照乐谱本身唱出独唱部分。虽然仅限于在键盘音乐上使用,但逐渐也出现了使用特定符号指名的装饰音。自由装饰在 17 世纪到 18 世纪的音乐演奏中占据越来越重要的角色,用特定符号指定的装饰逐渐形成了一个系统。但是由于早期装饰音的独特写法以及缺乏统一连贯性,如何正确诠释装饰音符号就成了一个大问题。相同的装饰音有时却有不同的符号和名称,而不同的装饰音有时又用相同的符号来代表。一直到葛路克(Gluck,1714—1784)开始,作曲家们才逐渐控制装饰音在谱面上的使用。他们将自己所要求设计的装饰音奏法尽可能清楚地在谱面上标写清楚,用最简单的符号来表示最难的装饰音。自此,如何演奏装饰音再也不是大问题,被称为特别的装饰(本质的装饰)。而在莫扎特的时代,关于使用装饰音的各方面都已经很完善明确了。莫扎特使用了非常多的装饰音,并且在钢琴乐曲中也使用了大量的装饰音。他认为每个活生生的、自由的演奏家都一定有自己的个性和演奏技巧。因此在弹奏乐曲时,一定会有自己的演奏变化与特色,或者会将自己的兴趣及意见用装饰音演奏出来。所以莫扎特使用装饰音相当自由,他认为在适当的时间或者音符上使用合适的装饰音是非常重要的。在莫扎特的作品中,最常见的装饰音符号有:代表倚音的小音符,代表回音的符号,以及表示震音的符号。他注重强调音乐的连贯性,并在力度上讲究渐强渐弱的变化。

## 2.3.2 融合其他音乐家的创作元素

莫扎特的音乐被认为是各国风格的综合体。由于他多年游历欧

洲和学习的经历,他拥有多种创作的风格。除了受到父亲利奥波德的教导外,无论是当时还是现在,人们都可以在莫扎特从小就开始的各地学习经历中找到他音乐风格的根源和各种影响。

#### 2.3.2.1 约翰·肖伯特对莫扎特音乐风格的影响

在巴黎期间,年轻的莫扎特对约翰·肖伯特的音乐风格产生了浓厚的兴趣,在自己的一些奏鸣曲作品中融入了肖伯特的创作技巧。肖伯特在羽管键琴作品中,运用快速的声音形状和密集的和弦编织来模仿管弦乐的效果。这种技巧在莫扎特的作品《欢腾喜悦》中非常明显。莫扎特也利用这种方法得到了很好的伴奏效果。有研究人员认为,莫扎特形成优雅而富有诗意的风格,离不开肖伯特作品的帮助。

#### 2.3.2.2 约翰·塞巴斯蒂安·巴赫对莫扎特音乐风格的影响

在伦敦期间,莫扎特认识了约翰·塞巴斯蒂安·巴赫,他对莫扎特后来的创作风格产生了巨大的影响。莫扎特和巴赫都创作了多种体裁的作品,巴赫吸收了意大利歌剧的特点来丰富自己的创作。巴赫曾将歌颂国王的世俗音乐作品中的一个或几个乐章借用到歌颂上帝的宗教作品中,这种方法极大地启发了莫扎特。1772年,莫扎特将巴赫的三首奏鸣曲改编成钢琴协奏曲(K.107.1-3)。随后,他在博洛尼亚跟随神父乔瓦尼·巴斯蒂塔·马尔蒂尼学习对位法。在莫扎特在1770年至1773年间创作的交响曲中,我们可以感受到马尔蒂尼和其他意大利作曲家的影响。

#### 2.3.2.3 约瑟夫·海顿对莫扎特音乐风格的影响

1773年夏天,莫扎特在维也纳再次接触到约瑟夫·海顿的音乐。海顿对莫扎特创作的影响日益重要。莫扎特模仿海顿的风格创作了K.183和K.201交响曲,并结合了自己的创作风格,使得这两部作品非常独特。其中,K.183又被称为"g小调"交响曲,因其强烈的严肃性和主题的统一性,结合莫扎特对交响曲整体形式的延伸方式,这部作品备受关注。因此,在创作《欢腾喜悦》这首经文歌之前,莫扎特经历了人生中几个非常重要的学习阶段。他整合了自己的创作风格,并融合了其他作曲家的创作元素。这些变化不仅体现在他的作

品中,也始终存在于他的内心深处。他的作品就像一面镜子,反映了整个音乐时代,使他的风格不仅是混合的,而是形成了一种新的风格。

### 2.3.3 独特创作技法"莫扎特风格"

文化史上有一个共识,莫扎特的音乐和歌剧是欧洲启蒙运动的产物。启蒙运动是一场复杂的思想运动,学者们对其本质特征的看法各不相同。此外,与其他时代的思想家一样,启蒙思想家关心的许多问题无法通过音乐或戏剧来表达。经验主义、自然神论和反教权主义并不是伟大音乐的素材。但是,许多基本思想和道德信仰启蒙运动的理念很容易通过音乐来实现,至少在那些拥有启蒙运动信仰的伟大作曲家手中。莫扎特无疑是一位作曲家,他对价值观有着深刻的理解。就像哲学家一样,莫扎特相信我们内心的思想和情感的力量是超越对抗的,由此形成了其独具特色的个人风格。

在莫扎特早期作品《降 E 大调交响曲》(K.16)中,有人发现在关系小调上,以反复的三连音和旋律上的一连音相对的第二乐章正是莫扎特出众的大量慢乐章中的早期范例。他在第 29—32 小节丰富多彩、生气勃勃的织体创造可以体现出他作为神童的机敏。而在情绪非常不同的末乐章也表现出了超强的创造力。在 1764 年的 8 月至 9 月期间,莫扎特在作曲上投入了大量的时间,在此期间他进行了大量的对位实验、和声和节奏的结合练习,进行了无穷无尽的探索。他创作了一个用来习作的小册子"伦敦曲集",里面记载了他感兴趣的、随时想到的东西。在"伦敦曲集"中,有一首在 G 小调上的作品(ACM 36;K.15p),这一调性后来在莫扎特的创作作品的调性布局以及"表情性"中占据了重要位置。这首曲子的结构可以作为奏鸣曲或交响曲的平衡的二部曲式末乐章,其中重复音或颤音音型占有很大的优势,这使人们认为它可能会用来配器并成为某部交响曲的一部分。然而,在这一结构之下,年轻的莫扎特仍然竭尽全力地试图造成最大限度的非对称性。开始时的五小节单位在反复时被省略了,但在该乐章的后半段,一个五小节乐句和一个四小节乐句达成了平

衡。即便是在各部分结束时（第26—33小节和第65—72小节），一个八小节的乐句也被分成了"3+3+2"的节奏单位。其他因素使得这一由乐句的省略带来的出人意料的不规则性和力度感进一步加强。开始时连续减七和弦的运用在1790年之前的任何时代都是极不寻常的；节奏动机八分休止及其发展形式的大量出现造成了很强的一致性和紧张感；最后，向调式音阶上大六度调（E小调，第47—56小节）的调性偏离在这样一首小曲内部造成了可以想象的最大限度的调性对比。也许K.16的交响曲也不如这首曲子这样集中展示出莫扎特的早年天才特质。与此同时，巴洛克实践的各种遗迹在他的创作中逐渐消失。他为独奏键盘乐器而作的两套《荷兰主题变奏曲》（K.24和K.25，大约于1766年3月7日之前在荷兰写成）对演奏者的要求没有同时期的带伴奏的奏鸣曲那么高。但是也有有趣之处，一方面，他用一个柔板变奏作为每一组的结束，这在他后来的变奏曲中经常用到；但在另一方面，这两组变奏曲从头到尾保留了相同的节拍，这是莫扎特后来实践中避免的。

　　他创作的两首为钢琴二重奏而作的奏鸣曲K.19d（1765）和K.123a（1772）更加有趣。克里斯蒂安·巴赫和沃尔夫冈做过即兴的二重奏表演，利奥波德曾夸耀说，莫扎特在伦敦写下了第一首钢琴四手联弹作品，并且他还补充道："此前没有人写过一首四手联弹的作品。"K.19d的开始时是一个大人和一个孩子联弹的形式，他们一个演奏，另一个模仿，但是很快就变成了一个主旋律和伴奏的状态。关于后一首奏鸣曲，莫扎特本人确立了其室内乐体裁的特质。

　　他最初出版的作品是两首带可自由选择小提琴声部的拨弦古钢琴奏鸣曲（K.6和K.7），在1764年从早年的作品中整理而成，题献给法国的维克多丽公主。这两首作品最初是为独奏键盘乐器而作的，可供选择的小提琴声部是为了适合当时流行的巴黎趣味而增添的。在这些"集腋式"的奏鸣曲中，K.6由四个乐章组成，即"快乐章/慢乐章/小步舞曲和三声中部/快乐章"，而K.7则采用当时通行的"快乐章/慢乐章/小步舞曲和三声中部"的维也纳模式。K.7的慢乐章是后来被提到的"如梦的行板"中的第一个范例。这个乐章的织体中间

是一个连续的十六分音符三连音进行，下方是低音伴奏，上方是二连音的歌唱性主题组成。

还有两首奏鸣曲（K.8 和 K.9）紧随其后，题献给一位特塞伯爵夫人。在这第二首中似乎可以看出相对于之前奏鸣曲的某种风格进展，这不仅体现在其第一乐章对类似于"假再现"手法的有效运用，或是其绵密而流动的低音线条，而尤为突出的是其织体的多变性。

这两部的集子以 Op.1 和 Op.2 的名义在巴黎出版。随后出版的是 Op.3，这是一套带小提琴和大提琴伴奏的六首奏鸣曲，出版于伦敦，题献给夏洛特王后。从其中三首都是两乐章的形式可以明显感到克里斯蒂安·巴赫对莫扎特的影响。伴奏的小提琴声部按照典型的手法填充在乐句的结尾处，成为联结键盘声部不同旋律素材的桥梁；而大提琴声部执行着通奏低音的职能：有时重复键盘的低音线条，有时对其进行简化。

莫扎特最初的七首弦乐四重奏是全家返回萨尔茨堡之前于 1773 年在意大利写作完成的。第一首是 K.80，也是最不典型的一首，1770 年作于洛蒂，被认为受到了乔万尼·巴蒂斯塔·萨玛尔蒂尼的影响。这一作品最初是三乐章的形式（第四乐章是后来加的），写法和沃尔夫冈后来关于弦乐四重奏的理念极不相符。在前两个乐章中，大提琴和中提琴具有通奏低音式的功能，与此同时，大多数旋律素材都按照三重奏鸣曲的风格分配给小提琴声部，从谱面上看与大多数同时代的交响曲相似。

接下来的六首四重奏，K.155—160，很可能于 1772 年末和 1773 年初作于意大利。虽然没有一份手稿注明了日期，但看起来是被作为一整套按下五度循环圈来构思的，其调性安排依次为 D、G、C、F、降 B 和降 E。

到 1772 年，莫扎特将早期作品中不尽如人意之处尽数抛开。他的旋律的构造遵循连贯和自足的原则；短小的乐句在前后的关系中相互平衡，这种关系不仅仅由节拍和节奏构成，也通过旋律的上升和下降，与倒影和终止式极为相似。

在维也纳之旅时，莫扎特在他们富有的朋友梅斯梅尔医生家上

演了他的小歌剧《巴斯蒂安与巴斯蒂安娜》。这是莫扎特最早的一部完全保持了其演出影响力的戏剧作品，以卢梭的成功之作《乡村占卜师》(1752)为蓝本。作为一部典型的歌唱剧，它有着短小而旋律完整的声乐曲，后者被称为"咏叹调"，也称作是分节歌。莫扎特在欧洲巡演前后，在为不同的声部写作歌剧咏叹调方面已经有了丰富的经验。他已经习惯于表现任何戏剧情绪，并且随心所欲地写作甜蜜或愤怒的歌曲。他创作了《阿波罗和扬钦图斯》，被认为是一部幕间剧，是根据喜剧性的拉丁文歌词创作的。这部歌剧由一首单乐章的小型序曲和随后的宣叙调与咏叹调构成，其中某些段落不乏抒情性之处。第7分曲是为一位刚刚失去儿子的绝望父亲而写的咏叹调，歌词描写他仿佛是暴风雨的海面上颠簸的一叶孤舟。人声声部和乐队伴奏都呈现出年轻的莫扎特通过创作音乐图景烘托情感性内容的灵气。每小节的力度都在变化；旋律线不断从高往低、然后再往高移动。所有歌剧的构成要素共同作用，勾勒出极度痛苦的灵魂和被风浪折磨的帆船。莫扎特对乐队的处理堪称范例，他超越常规，创作适宜于戏剧表现的织体的能力让人惊叹。悠长而如歌的二重唱旋律（第8分曲）由第一小提琴演奏，低音提琴与第一小提琴分别用强拍和弱拍上的拨弦为之伴奏，这时，"分部"的中提琴用力拉出十六分音符，这似乎在预示着《女人心》中的管弦乐手法。相对于这一时期晚些时候为意大利和维也纳而写的作品，从《阿波罗》一剧中，我们能找到更为老练的技巧和更为生动的音乐想象力。莫扎特的喜歌剧《巴斯蒂安与巴斯蒂安娜》展示了莫扎特作为短小的、旋律化的小咏叹调大师。他在简单的、歌曲式的结构之上也能创作复杂的变化和必要的花腔，就如同他写作意大利咏叹调一样。莫扎特第一部真正风靡于世的正歌剧是1770年来自米兰的委约之作。《本都王米特里达特》(K.87)的剧本被认为是"莫扎特所曾拥有的最好的正歌剧台本"。莫扎特为意大利写的最后一部歌剧是《卢齐奥·希拉》，是由乔万尼·德·贾梅拉(1743—1803)编剧的正歌剧。贾梅拉采用梅塔斯塔西奥式的有助于世道人心和道德说教的口吻，设计了一个关键情节，由爱情的忠贞转向对朋友的不忠和背叛。最后，独裁者希拉没有处死罪人来惩戒

背叛的行为，而是作出了宽恕一切的包容姿态。剧中六个角色分为两种类型：四位女高音和两位男高音。尽管这部作品的台本因循惯例，莫扎特却借此证明了他飞速发展的个人风格。在这部歌剧中，乐队被给予了更重要的地位，其效用远远超过了在《米特里达特》和《阿斯卡尼奥在阿尔巴》中的表现。丰满的织体让人想到的不是简单的伴奏功能，而是各个声部都有机地作用于整体的室内乐风格。虽然带有大量的花唱，但咏叹调仍然占有主导地位，咏叹调类型的排列更加丰富多变。而在旋律与和声手法中，可以看到作曲家未来发展的最为清晰的迹象。在歌剧快要结束时，男主角用小步舞曲的速度唱了一首咏叹调，旋律流畅、甜美，加上器乐声部强有力的支撑，营造出难以忘怀、感人肺腑的效果，可媲美莫扎特最成熟时期的佳作。尤为引人注目的是他用来表现复杂情感的和声语汇。莫扎特的评论家公认，作曲家能够将喜剧和悲剧、幽默与哀伤以一种无可比拟的至高境界熔为一炉，他晚期的歌剧《唐·乔万尼》和《女人心》可以说是这一类型的巅峰之作。在《卢齐奥·希拉》中，莫扎特以两种不同的方式处理两个相似的戏剧场景。在第一个场景中，女主角朱尼娅拒绝了暴君希拉的求爱，因为她坚信是他杀死了她的丈夫。朱尼娅的咏叹调开始时是缓慢而沉思性的，其中诉说了她对丈夫的爱，接着她又演唱一个快速的段落拒绝了现在的追求者。回忆与现实的交替造成了一个带尾声的 ABAB 的结构。这种包含巨大情感幅度的咏叹调在过去并不罕见。在第二个场景中，被认为已死的、计划杀死希拉的丈夫塞西利奥唱了一首并非返始形式的咏叹调，描绘了他混杂着希望和愤怒的复杂心情。这首咏叹调的主调是 D 大调，但下属调域却常常浮现，在 G 大调和 G 小调之间摇摆，再加上互相配合的强有力的节奏支撑和小号与定音鼓构成的配器，仿佛是《唐·乔万尼》在地狱大门打开那一刻的预演。

莫扎特创作风格的大胆在全世界都是显而易见的。莫扎特的宗教声乐作品在改变古老的经文歌刻板印象的同时，大胆创新，借鉴了许多器乐作品的创作手法，使他的宗教音乐风格宏大、有力、歌剧化，带来了广泛而有力的情感释放。如此直接的情感表达与其他神圣音

乐作曲家完全不同。比如,伟大的作曲家巴赫就是一位宗教音乐大师。他的创作风格谨慎而保守,小心翼翼地表达了他对上帝的敬畏和热爱。巴赫的宗教音乐风格反映了人与上帝之间的巨大距离。巴赫的宗教音乐被后世形容为"最接近上帝的声音",因为上帝的权威是不容置疑的。但莫扎特不同,他就像一个被宠坏的孩子,他创作的音乐似乎动人地传达着上帝的爱。莫扎特的风格与大多数作曲家不同。在他的音乐中,很难听到人们的痛苦、迷茫、矛盾的情绪。莫扎特晚年饱受疾病困扰,变得懒惰、郁闷。仅有的一点薪水已经无法养活他和他的家人了。有人曾说莫扎特的音乐性是"纯粹的音乐性",但他的作品所表达的却是最真实、最好、最美的音乐本身,具有纯粹性和灵性。他的音乐如珍珠般美丽透明,如阳光般热情热烈,充满青春活力,甚至在其最复杂的音乐形式中没有一丝打磨的痕迹。他的音乐里没有多少忧郁和黑暗,即使有,他也只是默默地独自承受鞭打,依靠自己明确的信念,用温暖、甜蜜的话语来安慰别人和自己。莫扎特本人曾说过:"我的内心是宁静的。并不感到疲乏。我是乐知天命、心怀坦荡、无所畏惧的。人生曾经是多么美好,在极其幸福的境况中,我开始了我生命的运行轨迹。直到今天,命运依旧是这样待我不薄。"

### 2.3.4　莫扎特的音乐创作特征及对后世音乐发展的影响

莫扎特的创作技法不仅体现了古典主义音乐的风格和美学,而且对后世音乐家和音乐发展有着深远的影响和启示。莫扎特的创作技法与其个人经历、性格、情感等因素有着密切的关系。

莫扎特从小就展现出了非凡的音乐天赋。在父亲的教导下,他学习了各种乐器和作曲技巧。他的早期作品受到了巴赫、海顿等大师的影响,也体现了他对不同音乐风格和形式的探索和创新。莫扎特在少年时期就开始了漫长而艰辛的欧洲巡演,他在不同的国家和城市结识了许多音乐家和贵族,他的音乐视野和知识得到了拓展和丰富,他的作品也反映了他对不同文化和风俗的观察和吸收。莫扎特在成年后,为了追求自由和独立,脱离了萨尔茨堡宫廷的束缚,定

居于维也纳，成为历史上最早的自由作曲家之一。他在维也纳时期创作了许多杰出的歌剧、交响曲、协奏曲、奏鸣曲等作品，展现了他对古典主义音乐风格的完善和发展。莫扎特的性格多变而复杂，他既有孩童般的天真和幽默，又有成熟而深刻的思想和感情。他的音乐也体现了这种多样性，他能够根据不同的场合和目的，创作出轻松欢快、悲壮感人、嘲讽讽刺、庄严肃穆等不同风格和气氛的音乐。莫扎特的情感生活也影响了他的创作，他与父亲、姐姐、妻子、儿女、朋友等人之间有着复杂而微妙的关系。他在音乐中表达了自己对亲情、友情、爱情等不同感情的理解和体验。

莫扎特的创作技法在旋律、和声、结构、配器等方面都有着精湛的水平，他能够根据不同的音乐体裁和情境，灵活运用各种音乐要素，创造出优美、流畅、富有表现力的音乐作品。他的音乐既有歌唱性和抒情性，又有戏剧性和对比性，既遵循古典主义的规范和均衡，又表达自己的个性和创新。莫扎特的创作技法也反映了他的个人经历、性格、情感等因素的影响，他的音乐作品具有鲜明的时代特征和社会意义。他在歌剧中揭露了贵族阶层的腐败和愚昧，赞扬了平民阶层的智慧和勇敢，体现了民主和平等的思想。他在《魔笛》中融合了多种音乐风格和文化元素，并暗喻了共济会的理念，展现了人类追求真理、美好和自由的精神。莫扎特的创作技法对后世音乐家和音乐发展有着重要的影响和启示。他在歌剧、交响曲、协奏曲、室内乐等各种体裁中都留下了经典的作品，为后来者提供了丰富的素材和范例。他在音乐形式、结构、配器等方面也做出了创新和突破，为贝多芬等浪漫主义音乐家的发展奠定了基础。他的音乐也对当代音乐教育和欣赏有着积极的价值和意义，可以培养人们的审美能力和情感素养。

莫扎特声乐作品的演唱技巧既朴实又华丽，虽华丽却不是为了"哗众取宠"。我们常常会听到有某一重要音节通过快速流动的音符做"无限性"延长，既有助于充分表现音乐内容，同时增加了演唱者的趣味性。他的声乐作品提高了歌剧的艺术水平和地位。他在歌剧中创造了多种风格和类型，如喜歌剧、严肃歌剧、神话歌剧、历史歌剧

等。他的歌剧作品被认为是古典主义时期的典范,对后来的浪漫主义和现代主义歌剧都有重要的影响。他对歌剧中的人物刻画和情感表达也达到了很高的水准,他的音乐能够反映人物的性格和心理,也能够表达不同的社会和政治观点。莫扎特的声乐作品丰富了声乐技巧和表现力。他在声乐作品中运用了各种装饰音、变奏、模进、对位等手法,使他的旋律既优美流畅,又富有表现力和想象力。他的声乐作品也展现了他对不同声部和声域的掌握和运用。他能够根据不同的声部和声域来创作适合的音乐,也能够利用不同的声部和声域来产生不同的音乐效果。莫扎特的声乐作品促进了声乐与器乐的融合和发展,他在声乐作品中赋予了器乐以重要的角色和功能。他不仅使用各种器乐来伴奏和衬托声乐,也使用了各种器乐来独立地表达音乐内容和情感。他在声乐与器乐之间创造了多种关系和对话,如对比、对位、模仿、回应等,使得声乐与器乐之间形成了一种有机的整体。而《欢腾喜悦》(K.165)是一部展现了莫扎特宗教声乐创作水平和风格的杰出作品,它对后世的声乐家和演唱家有着重要的影响和启示。

莫扎特的音乐具有丰富而多变的旋律。他的音乐结构清晰而灵活,他掌握了古典主义时期的各种音乐形式,如奏鸣曲式、回旋曲式、变奏曲式等。他也能根据音乐内容和情感的需要,对这些形式进行创造性的改变和发展。莫扎特的音乐和声丰富而精致,他善于运用各种和声色彩和转调技巧,使他的音乐具有多样性和魅力。他也是第一个在交响曲中使用单簧管和大号等管乐器的作曲家。他的音乐风格多样而独特,他能够根据不同的场合和目的,创作出轻松欢快、悲壮感人、嘲讽讽刺、庄严肃穆等不同风格和气氛的音乐。他的歌剧作品尤其突出了他对人物性格和情感的刻画和表达。

莫扎特的创作技法不仅体现了古典主义音乐的风格和美学,而且展现了他的个性化表现。他的音乐作品反映了他的个人经历、性格、情感等因素的影响,也表达了他的独特风格和创新意识。

莫扎特在歌剧中运用了丰富的音乐语言和手法,创造了生动的人物形象和情节。他能够根据不同的角色和场景,灵活地变换音乐

风格和气氛，使歌剧具有戏剧性和对比性。例如，在《费加罗的婚礼》中，他运用了多种音乐体裁，如咏叹调、二重唱、三重唱、四重唱、合唱等。其中分曲由宣叙调（即，用近似日常说话的节奏和语调进行演唱）分隔，伴奏乐器仅用羽管键琴。歌剧由一系列独立的音乐事件构成，每首分曲都有明确的开始和结束——这种分割如此明确的分曲，如果表演上佳，在每首分曲结束时观众都会报以热烈的掌声。这些基本的音乐单位在许多方面彼此相似。在这两部歌剧中，每段分曲通常持续3分钟左右。它们通常采用一个单一调性，运用固定的节奏、速度和乐队伴奏或者，如果不是上述情况，就采用两个对比性段落，一个慢，另一个快。旋律素材多次重复也是它们的特征。歌剧中还采用了多种音乐技巧，如模仿、对位、变奏、赋格等，来表现不同的人物性格和情感变化。莫扎特喜欢运用旋律惯例与和声传统，稳定持续的规则对称和清晰乐句划分，以及透明稳定的和声组织。

　　莫扎特在钢琴曲中展现了他的歌唱性和抒情性，以及他对钢琴音色和技巧的掌握。他能够用简洁而优美的旋律来表达深刻而细腻的感情，也能够用复杂而精巧的结构来展示高超而灵敏的技巧。例如，在《C小调幻想曲与奏鸣曲》中，他运用了多种音乐形式如幻想曲、奏鸣曲、赋格等，以及多种音乐元素如半音阶、装饰音、对位等，来表现悲壮而激昂的气氛。

　　莫扎特在室内乐中体现了对声部平衡和配合的关注，以及对不同乐器特点和可能性的探索。他能够使各个声部都拥有独立而富有表现力的旋律，也能够使各个声部之间产生紧密而和谐的配合。他还能够根据不同的乐器组合，创造出不同的音乐效果和风格。例如，在《降B大调单簧管五重奏》中，他充分发挥了单簧管的歌唱性和灵活性，使其与弦乐器形成了优美而动听的对话。

　　莫扎特创作了共7首祈祷曲、晚祷曲、赞美诗，9部清唱剧、康塔塔、宗教剧，17首教堂奏鸣曲，20部弥撒，25首宗教短曲。这些宗教体裁的作品，在莫扎特的六百多部作品中占据了很大的比例。

　　作为一名西方作曲家，围绕宗教音乐创作作品是一件很简单的事情，因为宗教与他们的生活息息相关。作曲家对宗教音乐的模式

结构都特别熟悉,宗教音乐也是许多作曲家的创作开端。

有人说:西方音乐是宗教信仰的产物。无论是声乐曲还是器乐曲的发展演变过程,与其说是一种艺术技巧的变换,倒不如说是人类灵魂需求的反映。在声乐作品领域中,宗教音乐往往让人觉得生涩并且很难去理解与演唱。而这部作品优美动人的音乐气质完全可以与歌剧咏叹调相媲美,是莫扎特早期宗教作品中最为著名的一部,出自莫扎特17岁之时。

莫扎特是虔诚的教徒。他对上帝的感激之情在莫扎特的书信中有所显露。这部作品《欢腾喜悦》首演时是阉人男高音演唱,现代声乐中女高音与假声男高音都适合演唱。有人将它与亨德尔的《弥赛亚》、巴赫的《欢呼上帝》相提并论,无疑这几部作品都是伟大的。只是莫扎特的这部作品比较轻巧,也比较富有亲切的气氛。它适合一个人的心境,似乎可以想象成是一个人内心情感的汹涌,而《弥赛亚》则是比较广大的集体的宗教情感。这部声乐作品创作于1773年,是莫扎特为阉人歌唱家写的。这个时候的莫扎特精神状态相当不好,成年后的莫扎特生活很不好,过度疲劳与纵情使得他身体很快垮了。透过这个作品我们除了感受到莫扎特那天使般音乐的美,也许可以听到一些悲凉。我们温暖感动之余,不免会想象莫扎特当时的境况。虽说是宗教经文歌,但它无疑是莫扎特真情流露之作。正如莫扎特的其他声乐作品一样,它是许多声乐艺术家的保留曲目。这部作品中最常被演唱的是第四部分的《阿利路亚》。虽然是赞美上帝,但是曲调欢快,没有像其他宗教歌曲一般缓慢庄严,而是在热情欢快的气氛中结束。

/ 第 3 章 /

# 《欢腾喜悦》的演唱心得

## 3.1 女性演唱者的过去

在 16 世纪的欧洲,由于不允许女性在公开场合参与音乐表演,所以女高音的声部一直由男童声所代替。诚然,童声的音色给人的感觉比较清澈、纯净。但是其暴露的一些问题也不容忽视。童声在音域上的限制会在一定程度上影响作曲家的创作,在表现力上也存在一定的不成熟性。而且,童声能够利用的时间较短,随着男童变声期的到来,培养和使用存在很不经济的比例差。虽然,在当时还存在男性用假声演唱女高音的情况,但整体的音响效果并不理想。随着歌剧的不断兴起,女高音声部的解决成为重要的问题。在这一时期出现了被称为 castrato 的歌唱家群体。莫扎特作品 K.165 就是为阉人歌唱家费南齐欧·劳齐尼创作的。阉人歌手首先由梵蒂冈教会使用。到了 1870 年,意大利首先宣布阉人歌手不合法;1902 年,教会正式宣布永久禁止阉人歌手在教会演出;1922 年,随着最后一个阉人歌手的去世,持续了将近 300 年的阉人歌手才正式离开了历史舞台。

16 世纪的油画上开始出现了女性表演者与乐器,她们在家而非在学校学习到乐器演奏和演唱。16 世纪之前,除了极少数著名的女性音乐家外,女性在音乐生活中出现得极少。随着作曲家兼教师卡苏拉那(活跃于 1566—1583 年)和"女子音乐会"(Concerto diDonne,费拉拉宫廷的女性表演者群体)的影响,这一状况从 16 世纪中叶开始有所改变。即使像莫扎特的亲姐姐南内尔那般天赋异禀的女性,

也在18岁时,完成了自己最后一场演出后,在社会的偏见中彻底告别了音乐生涯。直到19世纪,女性依然不被允许进入音乐学院学习。所以,相当长的时间里,广大的女性几乎没有机会得到完整而系统的音乐教育。

## 3.2 《欢腾喜悦》中的拉丁语

1773年在米兰,作曲家用了三周的时间对这部套曲进行了创作。作品主要分为四个部分,有三个乐章和一个宣叙调,皆用拉丁文进行演唱。作品虽然是一个声乐套曲,但是大量蕴含着咏叹调的表现感觉。在唱词方面,一定要注意语言的发音。在字母的元音长短和清浊辅音方面要仔细学习。特别是个别字母的连读要尊重语言的习惯。众所周知,歌唱和语言的关系至关重要,声乐就是语言艺术的一种夸张表现。只有对语言的发音有着深刻的了解,才能将其进行较为贴切的表达。

拉丁语隶属于印欧语系—意大利语族,早期是意大利拉齐奥区的地方方言,后为罗马帝国所使用。伴随着罗马帝国的活动从而影响着欧洲语言系统的形成。拉丁语现在主要的应用是在一些特定的仪式场合、古代诗歌文学,以及医疗、化学、植物学等专业术语领域。拉丁语所使用的字母系统,大约形成于公元前7世纪,它以早期希腊字母、后期埃特鲁斯坎字母为基础,将原有的26个埃特鲁斯坎字母改为21个。原来的拉丁语字母是:A、B、C(代表/g/和/k/)、D、E、F、Z(希腊语的zeta)、H、I(代表I和J)、K、L、M、N、O、P、Q、R(虽然在很长一段时间内写成P)、S、T、V(代表U、V和W)、X。后来,希腊字母x废弃不用,代之以一个新字母G。在公元前1世纪,希腊被征服后,采用了当时通行的希腊字母Y和Z,把它们放在字母表的末尾。这样,新的拉丁语字母包含23个字母。直到中世纪才加上J(区别于I)和字母U和W(区别于V)。

拉丁语的发音,实际上是现代人根据拉丁文书面材料诵读时的发音。其单音节词内部无所谓轻重音。多音节词的重音位置通常集

中在倒数第二或第三个音节上,而且与音节的长短有关。音节的长短与元音的长短有关,其中,含有长元音的音节一定是长音节;同时还与音节的构成有关,闭音节无论元音长短都是长音节。在一个包含三个或三个音节以上的词中,倒数第二个音节如果是长音节就读重音,如果是短音节,重音就移动到倒数第三个音节上。

在这部作品中,"O vos animae beatae"要特别注意尾音 e 的发音,千万不能将其吞掉,要注意发音的明确。而歌词"vestro respondendo"则需要注意 o 这个音。同样的例子还包括"Tu virginum corona, tu nobis pacem dona"中的 a 字。总体来说,要求我们在咬字的时候首先必须把每个元音都要咬清楚,做到明晰而且圆润,不能唱的时候把元音吞掉,每一个元音都得发得很清晰干净,不要含糊不清,自然清晰圆润地归到词的尾韵上①。

在语言声调的基础上,我们还必须了解作品每个单词与语句组合的含义。声乐的演唱,并不是单纯的模仿,要使得演唱的情绪得到最大程度的渲染,就必须清楚自身所发出的每一个声音的意图。这种意图不能仅仅停留在大情绪靠近的阶段,要想更为细致地进行情绪表达,必须了解唱词的具体含义以及和乐句之间的关系。

## 3.3 《欢腾喜悦》的演唱提示

这首作品整体是以赞颂为主的情感。但是莫扎特将其表现手法设计成抒情与欢快皆有的结构。在一开始的第一乐章中,莫扎特用了欢快的音型,在伴有花腔的演唱中要注意声音的控制。抒情段落要调整音色效果,既不能过于喧闹,也不能声音太靠后而发闷。花腔的弹性要高,在保持音准的同时,声音要灵巧。在演唱这段花腔时,要保持一个平稳的心态,切不可当作歌剧中的大型咏叹调来处理。要寻找其适用于音乐的抒情歌颂感觉,不能抱有炫技的心态。

---

① 贾棣然,周小燕. 莫扎特女高音音乐会咏叹调 20 首下[M].合肥:安徽文艺出版社,2010.

从作品创作的时期来看，此时的莫扎特在创作方面呈现出变革的状态。一方面，由于萨尔茨堡的传统被科洛雷多所改变，创作呈现出结构简洁的意味，包括 K.165、K.192 和 K.194 的作品就可以充分证明这一点：三者都包括最少的单词重复、简单的合唱朗诵和对文本含义的音乐处理。但是他的创作并不拘泥于此。另一方面，莫扎特本人的创作也受到了意大利风格的影响。他将世俗音乐的元素带进自身的创作之中，作品呈现出富有华丽感的咏叹调风格。此时的欧洲，正在受到启蒙运动的影响，人们开始崇尚自由解放、风格质朴的音乐形式。不再被宫廷音乐或是仪式感过于浓重的音乐形式所束缚。这一社会变革的影响，在莫扎特的音乐中淋漓尽致地体现了出来，他逐渐开始关注自身的内心世界，不再一味地创作讨好宫廷和贵族的音乐。

当时的声乐作品，主要呈现出音乐朴实而具有流动感，整体较为平和典雅，并没有过大的情绪起伏，着重于歌颂对美好事物的赞美与向往。因此，作曲家在写作方面十分重视音乐的情绪平稳，从而体现出这一时期的整体审美风格。在创作中，莫扎特运用了很多歌剧式的写作手法。整体音乐使用了协奏曲的创作理念，在整体平稳的大前提下，进行适当的装饰，使得音乐不至于过度沉闷。在乐曲的快速段落中，要调动自己对声音的控制，完成十六分音符的音形时要将气息控制与音准、速度和力度进行良好配合协作。正如乐器的演奏一样，在初始阶段，首先要进行呼吸的训练，避免在演唱快速段落时出现气息上浮的习惯。平稳而结实的呼吸是唱好整个作品的关键。无论是作品刚开始的长线条乐句，还是快速弹跳的花腔乐句，都需要良好的声音基础。

在气息方面，不能因为速度和音高的关系向上浮动，反而要向下找支撑点。调动横膈膜的肌肉控制呼吸，用气息来吹动声带发声，而不能拉扯声带挤出高音或是花腔效果。还要正确处理喉头的位置，不能过分下压或来回变化，使其稳定，从而让声带运动与呼吸密切配合。调整应用机能，无论在唱高音、中音还是低音时，都要保持音色的统一。特别是在进行强弱不同的音乐处理时，应当结合自身的条

件与训练阶段,合理进行音量的输出,以得到较为理想的声音效果。除此之外,共鸣腔的使用也至关重要。

在音准方面,二度音程的音准是首先要注意的。在第一乐章的开始,器乐部分和人声交相辉映,这种和谐的进行如果被人声的准确性所影响的话,会导致作曲家整体营造的氛围被破坏。因此在练习中,要先跟随钢琴放慢速度进行跟唱与模唱。待音准能够保证准确的时候,慢慢加快速度进行训练。而面对乐章中的十度音程大跳,则更应该按照这种方式进行练习。在将音准处理完毕之后,还要将乐句与音高进行配合练习,在呼吸方面做好划分,不要将乐句断开。呼吸气口的划分是顺利完成音乐的关键,而在现实的应用过程中,这方面的个体差异性比较大,演唱者应当结合旋律与歌词大意的发展,配合自身的演唱能力与习惯进行个性化的处理。所要注意的是,对于长的乐句一定要有预备式的呼吸,能够较为完满地完成长线条乐句。

第一乐章结束后的宣叙调是演唱者可以休息的时刻。但是语气与音准仍需要准确,尤其是到了这一句,"Undique obscura regnabat nox",意为"曾经的笼罩着世界的黑暗",与宣叙调开头的第一句"Fulget amica dies",意为"美好的日子闪耀光芒"应当形成对比。分析歌词得到整个宣叙调都是笼罩着美好的气息,只有"黑暗"一词,演唱时需要有"说唱"的感觉。

对于宣叙调来说,其诞生在 16 世纪,到 17 世纪逐渐发展为带有朗诵性的乐曲。而在 1650 年之前,歌剧中最激烈的激情时刻通常以朗诵的形式呈现,通常是长篇独白。这种形式在 18 世纪德国作曲家亨德尔进行创作时得到了丰富,同时融入了德国的传统,从而变得更有表现力和多样化。之后克里格将其引入了康塔塔体裁,吸收意大利歌剧元素,从而引起巴赫等人的关注,开始效仿创作。从当时的情况来看,宣叙调虽然有着德国的音乐传统,但外在上基本上还是意大利歌剧的一种用语习惯,且被大量地应用在世俗音乐中。

无论怎样,莫扎特以其高超的音乐才能,在他的时代创造了音乐艺术的辉煌,为后世留下了丰厚的艺术成果。在现当代的艺术演绎

中,只有深刻认识到作曲家赋予作品本身的重要艺术内涵,才能够较为全面地进行艺术演绎。这种对内涵的了解一部分来源于对作品的音乐本体分析,了解其创作的意图与规律;而一部分则归结于当时的社会背景与艺术家的经历。将两者有效结合,结合自身的声乐能力,才能呈现出较为理想的艺术效果。

/ Chapter I /

# Mozart's Artistic Career

Wolfgang Amadeus Mozart was born in Salzburg on January 27th, 1756, and died in Vienna on December 5th, 1791. He was an Austrian composer and the son of Leopold Mozart. His style essentially represents a synthesis of creative elements from various periods. By 1781, these styles had become a hallmark of his time in Vienna and are now regarded as the epitome of Viennese classicism in the contemporary music world. His music is renowned for its beautiful melodies, elegant forms, and rich harmonies and textures. While rooted in the instrumental tradition of Austria and South Germany, he was profoundly influenced by Italian opera. He is widely regarded as one of the most significant composers in the history of Western music.

Initially, Mozart was referred to as Johannes Chrysostomus Wolfgangus Theophilus. The first two names commemorate the feast day of St. John Chrysostom on January 27th, while Wolfgang was the name of his grandfather, and Theophilus was the name of his godfather — benefactor, Johann Theophilus von Hagenauer. Mozart was the seventh and final child of his parents, Leopold Mozart and his wife Maria Anna, née Pertl. Among numerous siblings, only he and his fourth sibling, Maria Anna, survived. The surname Mozart was first documented in 1331 in Feschach, associated with Heinrich Mozart, as the Mozart family had been present in various villages southwest of

Augsburg since the 14th century, particularly in Heiningen. The paternal ancestry of this family can be traced back to Andreas Mozart, residing in the Augsburg area in 1486. Many early members of the family were involved in trades such as masonry, architecture, craftsmanship, and sculpting.

## 1.1 The First Decade of Mozart's Career (1760—1770)

His early education was entirely overseen by his father, Leopold, encompassing not only music but also mathematics, reading, writing, literature, languages, and dance. Additionally, at the time, a court singer named Franz Anton Spitzer provided music guidance to the young Mozart. Demonstrating prodigious musical talent from a very tender age, Mozart's abilities were evident early on. In Mozart's sister's music book, Leopold noted that Mozart had learned some pieces by the age of four, many of which were unknown minnets. These compositions possibly originated from Germany and included works by composers such as Wagenseil, C.P.E. Bach, J.J. Agricola, and J.N. Tischel, as well as compositions by Leopold Mozart himself. According to Leopold, Mozart's earliest known composition, a small Andante and Allegro, dates back to 1761 when he was just five years old. Among his more significant early works are two minuet dances numbered K.2 and K.5 in F major, as well as the Allegro numbered K.3 in B major, composed between January and July of 1762.

Mozart's first public appearance took place in September 1761 at the University of Salzburg, where he participated in the performance of *Sigismundus Hungariae Rex*, a final play (Finalkomödie) by Marian Wimmer, conducted by Salzburg's Kapellmeister Ernst Eberlin. In 1762, Leopold evidently took Mozart and his sister to Munich, where they played the harpsichord for Maximilian III Joseph of Bavaria.

Although this journey is not documented in literature, it is orally recorded by Mozart's sister, Nannerl. The Mozart family's trip to Vienna lasted from September to December 1762. During this time, the children performed twice in front of Maria Theresa and her spouse, Francis Ⅰ, as well as in the homes of various ambassadors and nobles, garnering significant attention. Consequently, the trip was deemed a great success. The court also bestowed a generous remuneration upon the Mozart family and requested an extension of their stay. Additionally, they were invited to Versailles by the French ambassador, François Marie, and the Count of Loumont Castle.

On January 5th, 1763, the Mozart family returned to Salzburg. Mozart's father, Leopold, received a promotion and began attending major local events. Both Mozart and his sister participated in concerts during these events, earning high recognition from the people in their hometown. On June 9th, the family embarked on a three-and-a-half-year journey across Europe, passing through Germany, France, the United Kingdom, Switzerland, and other countries.

They arrived in Brussels on October 4th, 1763, after traveling through Munich, Augsburg, Ludwigsburg, and other cities. During their journey, they performed in various forms and held several public concerts. On January 1st, 1764, in Paris, France, the children performed in front of Louis XV, followed by public concerts on March 10th and April 9th at the private theater of Mélèxe on Rue et Porte Saint Honoré. While in Paris, Madame Vendome published two of Mozart's sonatas for keyboard and violin, works numbered K.6 - 9, marking his first published music. The Mozart family arrived in England on April 23rd and performed for George III. They had planned to attend a charity performance event by composer and cellist Carlo Graziani on May 23rd; however, due to Mozart's sudden illness at that time, the charity performance was canceled. Consequently, Leopold and his wife held

their own charity event on June 5th in the large room of Spring Garden.

The Mozart family left London on July 24th, 1765, traveling through Canterbury, Lille, Ghent, and Antwerp, and arriving in The Hague on September 10th. There, the children held two public concerts and performed for Princess Nassau Welburg, for whom Mozart later composed keyboard and violin sonatas K.26 – 31. On March 11th, Mozart returned to The Hague and composed *Gallimatias Music* (work number K.32) for William V's installation ceremony. In April, they returned to Paris, arriving in early May. The Mozarts stayed in Paris for two months; their patron, Baron Grimm, had early facilitated Mozart's reception there, earning him high social acclaim.

Subsequently, the Mozart family began their journey back. Their final stops included Dijon, Lyon, Lausanne, Zurich, and Danube Schengen, where they performed for Prince Fortenberg for nine nights. They departed from Danube Schengen, passing through Dillingen, Augsburg, and Munich, and finally arriving in Salzburg on November 29th.

Leopold Mozart is often portrayed as a stern and perfectionist impresario, but in reality, many of their grand performances were not meticulously planned in advance. When Leopold left Salzburg, he had not yet decided whether to journey to England. However, Mozart's popularity in London may have surpassed their expectations. By June 1765, they found themselves compelled to resort to low-budget public displays in the less prestigious Conhill market. Moreover, people today often underestimate the challenges of travel during that era, for example, the routes were frequently unsafe, and the journey was uncomfortable due to rough roads. Generally, touring was a costly endeavor at that time. Additionally, Leopold often encountered obstacles such as boycotts or performance prohibitions by potential competitors. Nevertheless, due to unforeseen changes in their itinerary,

the tour was extended for nearly two years, albeit accompanied by generous music rewards. At each stage of their travels, Mozart had the opportunity to access music not readily available in Salzburg, and to meet composers and performers who seldom ventured into southern Germany and Austria, thereby expanding his horizons. In Ludwigsburg, he encountered Nardini, while in Paris, he encountered Schubert, Ekard, and Honor, and became acquainted with their sonatas and the works of Laupach and C.P.E. Bach. Mozart later drew inspiration from these encounters to create concertos numbered K.37, K.39, K.40, and K.41. Their sojourn in London brought Mozart into contact with K.F. Abel, Giovanni Manzuoli, and most significantly, J. C. Bach, establishing lifelong relationships with them. Undoubtedly, their influence on Mozart would endure throughout his life.

It is safe to say that throughout the "grand tour", Mozart began to internalize his father's opinions on various national styles and strategies for public presentation. Perhaps more significantly, Mozart also echoed his father's negative sentiments about Salzburg, which he almost verbatim repeated in his letters from the late 1770s to the early 1780s.

Mozart stayed in Salzburg for nine months. During this period, he composed three vocal works: a Latin comedy titled *Apollo and Hyacinthus* for the University of Salzburg; collaborated with Michael Haydn and Anton Cajetan Adlgasser on the first part of the oratorio *Die Schuldigkeit des ersten Gebots*; and composed the work numbered K.42, *Grabmusik*. On September 15th, 1767, the entire family departed for Vienna. It is speculated that Leopold's visit coincided with the wedding of 16-year-old Archbishop Ioseph to King Ferdinand IV of Naples. However, Ioseph contracted smallpox and died the day after the wedding, plunging the palace into mourning. This forced Leopold to reroute his family from Vienna to Brünn (Brno) and then to Olmütz (Olomouc), where both Mozart and Nannerl suffered from mild

smallpox.

On December 10th, 1768, *the Vienna Diary* reported that Mozart's work received widespread applause and appreciation, being interpreted with exceptional accuracy. Additionally, during this month, he completed the composition of Symphony No. 48, K.48.

They returned home on January 5th, 1769, and remained there for nearly a year. In October, Mozart composed his work numbered K.66 for the celebration of his friend Cajetan Dominicus Hagenauer. Other significant works from this period include three orchestral serenades, numbered K.63, K.99, and K.100. Two of these may have served as finale music for the traditional year-end ceremony at the university. Additionally, there are works numbered K.117 and K.141, along with several sets of dance minuets numbered K.65a, K.103, K.104, and K.105. By the age of 13, Mozart had already established a strong reputation as a composer and performer in the local area. On October 27th, he was appointed as an honorary court composer in Salzburg.

Nearly two months later, on December 13th of that year, Leopold and Mozart left for Italy. The tour followed a pattern of regular performances, with stops in any town where concerts could be held or where Mozart was expected to perform for influential aristocrats. They passed through Innsbruck and Rovereto, arriving in Verona on December 27th. There, Mozart performed at the Accademia Filarmonica. On January 16th, Mozart held a concert in Mantua typical of his performances at that time. The repertoire included symphonies, concertos, sonatas, fugues, variations, formal renditions of arias, and his own improvisations. The *Gazetta di Mantova* praised Mozart's music as "unparalleled" in a report.

Afterwards, the Mozart couple traveled from Mantua to Milan, where Mozart performed several times at the home of Count Karl Fermian, the Austrian ambassador. Likely due to the influence of his

performances and compositions, Mozart was commissioned to compose his first opera *Mitridate* for the carnival in December. He and his father left Milan on March 15 for Lodi, where Mozart completed his first string quartet, numbered K. 80. Subsequently, they visited Parma, Bologna, and Florence, where Mozart met the castrati Manzolli and the British composer Thomas Linley. They then traveled to Rome and arrived in Naples on April 10th, where Mozart composed two or three symphonies, numbered K.81, K.95, and K.97. During his brief stay in Naples, Mozart gave several concerts and attended performances of Cimarosa's *Armida*. He and his father departed from Rome on July 10th, returning to the summer villa of Count Palavicini in Bologna, where Mozart completed Symphony K.84.

## 1.2 The Second Decade of Mozart's Career (1770—1780)

On October 18th, 1770, after the Mozart couple returned to Milan, the composition work for the opera *Mitridate, re di Ponto* officially began. In the following period, the opera underwent several rehearsals, two orchestral rehearsals, and two complete theater rehearsals. Regarding the composition of the orchestra at that time, Mozart's father provided useful information in a letter on December 15. The orchestra consisted of 14 first violins, 14 second violins, 6 violas, 2 cellos, It consisted of 6 double basses, 2 flutes, 2 oboes, 2 bassoons, 2 trumpets and 2 keyboards. The premiere was held on December 26th at Regio Dual Teatro. The opera, including ballet music, lasted for six hours. Although Leopold did not believe that the opera would be successful, it turned out that he was wrong. Mozart's opera achieved an unprecedented success, so that 22 performances were directly performed at that time.

Mozart left Milan on January 14th, 1771, and stayed in Turin, Venice, Padua, and Verona before returning to Salzburg on March 28th. The 15-month trip to Italy was an extraordinary success, widely covered by the international press. The Hamburg Staats-und gelehrte Zeitung described Mozart's "extraordinary and precocious musical talent" in a report sent from Rome on May 22nd. A newspaper also report on Mozart's concert in Venice on March 5th, 1771, summarizing the professional and personal achievements of Mozart's tour.

In fact, before they returned to Salzburg in March 1771, Leopold had already planned his next two trips to Italy. Regarding these two trips, the Mozart couple were in Verona when Mozart was commissioned to compose a serenade called *Ascanio of Alba* for the wedding of Grand Duke Ferdinand and Princess Maria Beatrice Richarda in Milan in October of the following year. In the same month, the Regional Ducal Teatro in Milan offered him a contract for the first carnival opera of 1773, *Lucio Silla*. As a result, Mozart spent only five months of the year 1771 at home, during which he composed *the Paduan oratorio*, *Regina Kohli* (K.108), *Litani* (K.109), and *symphony* (K.110). On August 13th, he and his father set off again and arrived in Milan on August 21st. On August 29th, they received in Alba a libretto for Ascanio by Giuseppe Parrini. In Milan, Mozart's Serenade was rehearsed on September 27th and premiered on October 17th. Afterwards, Mozart stayed in Milan until December 5th, when he created works titled *Concertoùsia Divertimento* (K. 113) and *Symphony* (K.112). He once attempted to seek a job in the court, but his application was actually rejected by Ferdinand's mother, Empress Maria Theresa.

Mozart's third and final trip to Italy began on October 24th, 1772. Mozart received the script and cast list for Milan's new opera *Lucio Silla* in the summer, and also arranged a recitation for it. When he arrived in

Milan, these were all adjusted to accommodate the modifications made by the poet Giovanni de Gamerra for the performance. He then wrote the chorus and composed the arias for the singers in turn. In the process of writing, Mozart first listened to each of their songs so that he could better match the music with their voices. In fact, this opera achieved mixed results after its first performance on December 26th, mainly due to the uneven cast and the quality of the work. Despite this, the opera has been performed 26 times here.

On March 13th, 1773, Leopold and Mozart returned to Salzburg. At this time, the so-called Mozart prodigy era gradually faded away. Although he later went to Vienna, Munich, Mannheim, and Paris, it is not an exaggeration to say that the 1770s were an era of his arbitrary rule in Salzburg. For the most part, his career as a performer and composer focused on his court activities and a small group of friends and patrons in his hometown.

In 1775, Koloredo ordered the reconstruction of the Bauhaus Theatre in Hannibal Garten, with the cost borne by the city, as a theater for plays and operas. The first theater troupe to perform there was directed by Carl Wahr, whose repertoire included the comedy *Der Zerstreute* (named after J.F. Regnard), with music by Joseph Haydn (Symphony No.60, *Ildis Trato*), and Gebler's tragedy *Thamos, König inägypten* was composed by Mozart. In 1780, Hikarned's theater troupe visited and Mozart created an aria for it.

Mozart created a large number of works between 1772 and 1774. This includes such as K.167, K.192, K.194, K.125, and K.195, Regina Coeli K.127, more than a dozen symphonies (from K.124 to K.202), keyboard concerto K.175 (possibly an organ concerto), two violin solos K.190, serenade K.203, suite K.131, K.166 and K.205, as well as the K.174 quintet. At the end of 1773, the Mozart family moved from their apartment in Gatredegasse to a larger apartment in

Hannibal Square (now Markat Square), the so-called Tanz Mestrhaus (Tanzmeisterhaus). Undoubtedly, this move reflects Leopold's awareness of his position in Salzburg society. This family was socially active, participated in shooting parties, constantly created music, and often received visitors. Mozart's father took him to Vienna in July 1773. The four months spent in Vienna were a productive journey for Mozart. He composed a serenade K.185 and six string quartets (K.168 - K.173). The strong style emanating from two of the quartets, K.168 and K.173, is traditionally considered as leading quartet by Mozart and Joseph Haydn, reflecting the collaborative creative style of the Vienna quartet at that time.

Mozart returned to his hometown from Vienna in late September. Apart from spending three months creating and premiering in Munich from December 1774 to March 1775, he stayed in his hometown until September 1777. Around this time, Mozart began to gradually withdraw from Salzburg court music, and communication between family members documented Leopold's frustration at not being able to find suitable positions for both of them. In the years 1770, 1771 in Italy and 1773 in Vienna, Leopold tried to find jobs that would allow his family to leave Salzburg. This was not the first time he had such an idea.

Mozart's focus on creating was not affected. This was the primary responsibility of all Salzburg composers, and his works from 1775 to 1777 included works numbered K.220, K.257, K.258, K.259, K.262, K.275, K.243, and dedicated K.277. Mozart became the chief composer of Salzburg instrumental and secular vocal music. His four violin concertos numbered K.211, K.216, K.218 and K.219, and his four keyboard concertos numbered K.238, K.242, K.246, K.271, Serenade K.204 and K.250, *Serenata notturna* K.239 and many suites, including K.188, K.240, K.247 and K.252, all date from this period. He also composed several arias, including *Si mostra la sorte* K.209,

*Con ossequio*, *Con rispetto* K.210, *Voi avete un cor fedele* K.217 and *Ombra felice … Io ti lascio* K.255. Mozart's cultivation of instrumental music was likely encouraged by Leopold, who in many cases created it for private sponsors rather than the court. Leopold was the most outstanding and successful local symphony and serenade composer during his heyday.

In the summer of 1777, Leopold felt that he couldn't afford to leave Salzburg, so Mozart left his hometown with his mother on September 23rd to travel again. The purpose of the trip was clear, Mozart was to get a well-paid job so the family could move. Mozart made contact with Munich, but was politely refused. In Augsburg, he held a concert featuring several of his recent works and met keyboard instrument manufacturer J.A. Stein.

Mozart and his mother traveled from Augsburg to Mannheim, where they stayed until mid-March. His Mannheim works include keyboard sonatas K. 309 and K. 311, flute quartet K. 285, five accompanying sonatas K.296, K.301, K.302, K.303, K.305 and two arias, *Alcandro lo deplaito … Non såd'onde viene* K.294 and *Se al labbro mio Non-credi … Il cor dolente* K.295. At that time, Ferdinand Dejean, an employee of the Dutch East India Company, had worked as a doctor in East Asia for many years. He wanted to commission Mozart to compose three flute concertos and two flute quartets, but ultimately failed to fulfill his wish. Mozart only composed one quartet. And the aria K.294 was created for Aloisia Lange, the daughter of Mannheim scribe Friedelyn Weber. That's because Mozart fell in love with Alois and proposed to Leopold the idea of taking her to Italy to become the chief soprano. However, this proposal angered his father, who accused Mozart of procrastination, irresponsibility towards money, and disloyalty to his family.

In February 1778, Leopold ordered his son to go to Paris and

decided to let his mother continue to accompany him rather than return to Salzburg, it was a decision that would have a profound effect on both father and son. Mozart arrived in Paris on March 23rd and immediately re-established contact with Green. He composed additional music for *Holzbauer's* performances of Les Misérables, mainly the choral work kA1. On June 18th, a symphonic piece by Mozart, numbered K.297, was performed at the Spiritual concert. *Les petits riens*, a ballet he wrote for Noverre, was played alongside the Piccinni opera *Le finte gemelle*. Mozart was very unhappy in Paris, and his mother fell ill in mid-June and passed away the following month. His father, Leopold, implied that Mozart was partly responsible for his mother's death.

Mozart spent the remaining time of this summer at the Greens' house. On September 8th, he performed another symphony at the Spiritual concert and met J. C. Bach. Before Composing the opera *Amadeus de Gaulle*, Bach came from London to listen to Parisian singers. Mozart set off for home on September 26th. Green had him take a slow train through Nancy, from Strasbourg to Mannheim, where he heard Benda's melodrama *Medea*. However, Leopold was angry that Mozart had gone to Mannheim, as there were no opportunities for promotion after Karl Theodor's court was transferred to Munich. Mozart arrived in Munich on December 25th and stayed until January 11th; he received a cold reception from Aloisia Weber, who was singing in a palace opera. Finally, in the third week of January 1779, he returned to Salzburg.

After Mozart returned to his home country, he immediately petitioned the court formally to appoint him as a court organist. His duties included playing at court and instructing the choir boys in singing. At first, he seemed determined to fulfill his duties. From 1779 to 1780, he composed *Coronation* K.317, K.337, K.321, and K.339, as well as *Regina Corelli* K.276. Mozart also composed the double

piano concerto K.365, the piano and violin sonata K.378; Symphony K.318, K.319 and K.338; *Posthorn* Serenade K.320 and Suite K.334; the Violin and Viola Concerto K.364, as well as incidental music for *Thamos*, *King in Egypt* and "Zaide".

## 1.3 The Last Eleven Years of Mozart's Career (1780—1791)

In the summer of 1780, Mozart was commissioned to create a serious opera for Munich and arrived in Munich on November 6th. This opera finally premiered on January 29th, 1781, and achieved considerable success. Leopold and Nannell from Salzburg attended the premiere. Afterwards, the Mozart family stayed in Munich until mid-March. During this period, Mozart composed the recitative and aria *Les Misérables* K.369, oboe quartet K.370, and three piano sonatas K.330, K.331, and K.332. On March 12th, Mozart was summoned to Vienna to celebrate the accession of Emperor Joseph II. He arrived on March 16th, and Mozart, who had just experienced success in Munich, felt angry for being treated as a servant.

Around this time, Mozart moved to his former friend Weber's house in Mannheim, and they moved to Vienna after marrying court actor Joseph Lange in Alois. At first, he lived a humble life and taught three or four students, including Joseph von Orenhammer, for whom he wrote sonatas K.448 for two pianos. Among his students were also Marianne Caroline, the Countess Thun (wife of Count Thun, Austrian ambassador to Spain), and a cousin of Johann Philipp von Cobenzl, a minister of state. Mozart also participated in various concerts or performed at concerts. On April 3rd, the German Music Association released one of his symphonies. On November 23rd, he played at a concert sponsored by Johann Michael von Ornhammer. Later, Mozart

took part in a series of Augarten concerts organized by Philipp Jakob Martin. On May 26th, 1782, at the first concert, he performed a double piano concerto with Joseph von Ornhamer. The first special concert held by Mozart here was on March 3rd, 1782, at the Berg Theatre. The concert program included concertos K.175, K.382 and K.415. He also regularly performed at the home of Baron Gottfried van Swetten, where Handel and Bach's works were the main repertoire.

By the end of 1781, Mozart had become the best keyboardist in Vienna. Although he is not without opponents, few could match his piano skills. The most severe challenge may come from Clementi. On December 24th, at the behest of Emperor Joseph II, Mozart and Clementi participated in an informal competition. It is obvious that Mozart felt uneasy about this incident. Although people believed he had won, and Clementi later generously talked about his performance, Mozart repeatedly belittled this Italian pianist in his letters. Clementi's skill might well have surprised Mozart, and the emperor must have been impressed, as he had been talking about the match for over a year. In the same month, Mozart's first Vienna publication was also published, which was a collection of six keyboard and violin sonatas numbered K.296, K.376, K.377, K.378, K.379, and K.380. They received positive reviews. A review in Kramer's *Museum Magazine* (April 4, 1783) described them as "unique among their kind", full of new ideas and traces of the author's great musical genius.

However, the most important work of this period was *Serail Entführung aus dem Serail*, whose lyrics were handed over to Mozart at the end of July 1781. The premiere, originally scheduled for September was postponed to the following summer (Mozart completed the first act in August 1781). The opera was a great success. Therefore, Gruck requested more performances. Sikandel's theater troupe performed independently in September 1784.

At this time, Mozart decided to marry Constanze Weber. On July 31st, 1782, Mozart wrote to his father asking for his approval, and on August 4th, they were married at Stephendorm. Leopold reluctantly agreed the next day. This marriage apeared very happy. Although Mozart described Constanze as lacking intelligence, he believed that she had "enough common sense and the kindest heart in the world". His letters to her, especially those he wrote during his tour in 1789 and during her treatment in Baden in 1791, were full of love.

Mozart also created several new works between 1782 and 1783, including the piano concertos K.413, K.414, and K.415, which were published by Artaria. Although Mozart may not have regarded them as a set, he thoroughly revised these three pieces and put them together in the spring of 1783. At this time, he also created three arias, K.418, K.419, and K.420. He planned to produce Pasqual Anfossi's *Il curioso increto* at the Berg Theatre on June 30th, 1783. At the same time, he began to create the so-called *Haydn* quartet. The first, K.387, was completed in December 1782; The second, K.421, was completed in June 1783, while Constanzer was giving birth to their first child, Raymond Leopold, on June 17th. Mozart and Constanze had six children, four of whom died during infancy. They were Raymond Leopold (1783), Carl Thomas (1784), John Thomas Leopold (1786), Theresa (1787—1788), Anna Maria (1789), and Franz Zefer Wolfgang (1791).

Mozart and Constanze finally traveled to their hometown in July. They stayed in Salzburg for about three months. Later correspondence suggests that the visit was not entirely pleasant — Mozart was anxious about the visit and about his father's reaction to Constanze. There, he composed two violin viola duets for Michael Haydn. On his journey back to Vienna, Mozart stopped in Linz, where he composed a symphony titled K.425 for a concert, and the piano sonata K.333 also

began at this time.

In late November 1783, Mozart returned to Vienna and entered the busiest and most successful period of his life. On December 22nd, he performed a concerto at a concert held at Tonkünstler Societät. On January 25th, 1784, he conducted a performance of *Die Entfü hrung* for Aloysia Lange. In March, he held three concerts in his private hall in Tratnahov. On April 1st, a grand concert was held at the Berg Theatre, featuring a symphony, *Linz* (K.425), a new concerto (K.450 or K.451), piano and orchestral quintet K.452, and improvisation and performance. The performance season of 1785 was also similar. Starting on February 11th, he held six concerts in Meergrube, featuring works including the Concerto in D minor, K.466. On March 10th, another concert was held at the Berg Theatre. From February 1784 to December 1786, Mozart composed over a dozen piano concertos, undoubtedly the most important of their kind. Perhaps in recognition of his rising stars, in February 1784, Mozart began preserving a catalog of his new work *Verzeichnüss aller meiner Werke*, recording the theme and date of each work. This directory is the main source of information about Mozart's creative activities in the 1780s, recording several lost works, including the aria K.569, K.565, and the Andante for violin concerto K.470.

In addition to public performances, Mozart also participated in private concerts. In March 1784 alone, he performed for 13 times, mainly at the homes of Count John Esthaci and Russian Ambassador Prince Golitz. For the same reason, local performers and concert organizations often release his newly commissioned works in their programs. On March 23rd, clarinet player Anton Stadler performed *Wind Serenade* K.361, and on April 29th, Mozart and violinist Regina Strenasacci performed *Sonata* K.454. These works and performances brought considerable praise to Mozart. Earlier that year, Leopold Mozart visited his son in Vienna in February and March 1785. He wrote

a letter to Nannell describing the quartet party held at Mozart's home. Haydn told him at the party, "In the presence of God, as an honest person, I tell you that your son is the greatest composer I know, both personally and by name. He had taste, and more importantly, he has the most profound knowledge."

Mozart had many publications during this period, including three sonatas, K. 333, K. 284, and K. 454, which were performed in Toricella. In July 1784, Lausch advertised manuscripts for six piano concertos, and in February 1785, Trag provided copies of three symphonies. However, the most important publications may be Artaria's three concertos, K. 413, K. 414, and K. 415, which were published in March 1785, as well as Artaria's six quartets dedicated to Haydn, which were published in September of that year. The success of these works seems to have fundamentally transformed Mozart's attitude towards composition and publication. After the middle of 1786, Mozart planned several works, which were mainly for publication rather than public performance, including piano quartet K.478 and K.493, triple piano trio K.496, K.542 and K.548, string quintet K.515 and K.516 in C major and G minor, Hofmeister quartet K.499, and piano and violin sonata K.526.

Although opera remained at the heart of Mozart's ambitions during this period, he did not have the opportunity to build on the success of *Die Entführung*. By the end of 1782, Emperor Joseph II decided to close the National Theatre (which he founded in 1776 to promote German culture) and re-establish Italian opera. Mozart quickly took advantage of this change, although he found it difficult to find a suitable script. Therefore, he requested Leopold to commission a libretto from the Salzburg poet and Idomeneo playwright Varesco. In early 1786, a single act comedy *Der Schausfieldirektor* K. 486 and Salieri's *Prima la musica e poi le paro* (both commissioned by the

Governor General of Austria Netherlands) were performed in Schloss Schönbrunn's orange orchard. In March, a private performance of the revised version of *Idomeneo* was held at the Prince Auersperg Theatre. Among other changes, Mozart created a duet called *Spiegarti non poss'io* (K.489) instead of *S'io non-moro a questi accenti*, and created scenes and *rondånon-piú, tutto ascotai ... non-temer, amato bene* (K.490) to replace the original opening of the second act.

The theme of Mozart's first collaboration with Lorenzo da Ponte was undoubtedly carefully selected. Mozart began composing *Le nozze di Figaro* in October and November 1785, and on May 1st, 1786, the opera appeared on stage at the Burgundy. The initial performance was a success. In the first three performances, many songs received applause and encores, which prompted the emperor to limit the later encores to the aria. The so-called provocativeness in this opera may have been exaggerated. Da Ponte carefully removed more provocative elements from Beaumarchais' plays, ensuring that the characters and events in the opera fully conform to artistic traditions. However, content reflecting social tensions still exists, such as the conclusion of Act 2 and the early music of Act 3. And the individual arias also reflected the social status of each character. However, in the end, *Figaro* was just a comedic domestic drama, despite reflecting contemporary concerns about gender and society.

Mozart barely maintained his life in Vienna by recruiting students. The most important student among them was John Nebomuk Hummer, who studied under Mozart from 1786 to 1788. Mozart had also taught British composer Thomas Atwood, and the practice books he kept proved Mozart's cautious and systematic teaching methods.

In 1787, Mozart accepted an invitation to Prague, where *Figaro* achieved great success. He remained there for about four weeks, from January 11th, 1787, apparently enjoying his popularity in the city. He

conducted a performance of *Figaro* and held a concert, which included a new symphony — Prague K.504, created for this occasion. At this moment, the Prague manager Pasqual Bondini commissioned Mozart to create an opera for the following autumn. After returning to Vienna, Mozart asked Du Pont for the text lyrics.

The plot of *Don Giovanni*, like *Figaro*, was based on class and gender tensions and can be traced back to the period of Tisso de molina (1584—1648), although *Da Ponte* draws from the latest stage versions, a single-act opera composed by Giuseppe Garzzaniga and a script written by Giovanni Bertati in Venice in February 1787. Mozart set off for Prague on October 1st, and the premiere was originally scheduled for October 14th, 1787. However, due to insufficient preparation, the performance of *Figaro* was forced to be cancelled, and the new opera was postponed to October 29th. Once performed, it was warmly welcomed. Mozart conducted three or four performances before returning to Vienna in mid-November. During this period, he also visited the family of his friend Dusek. He wrote the aria *Bella mia fiamma*, K.528, for his old friend Josefa in Salzburg. *Don Giovanni* was performed in Vienna in May 1788 and underwent several adaptations: in the second act, Leporillo's escape aria was replaced by a duet with Zelena; In the second act, "Il mio tesoro" was replaced by "Dalla sua pace" in the first act, and Elvira received a magnificent recitation and aria.

The collaboration on two operas with Duport, along with his increasingly successful publications, opened up a new stage in Mozart's career. On April 7th, 1786, less than a month before the premiere of *Figaro*, he held a grand concert at the Berg Theatre, which was his last concert at the venue, featuring works including piano concerto K.491 in C minor. Mozart's father, Leopold Mozart, died in May 1787, which may have opened a period of rest for the composer. Leopold's death

also marked the final dissolution of the Mozart family in Salzburg. At that time, only Nannerl stayed behind. In 1784, she married John Franz von Berchtold Zu Sonanburg and moved to St. Gilgen. Apart from resolving their father's inheritance, Mozart clearly did not maintain contact with her.

Mozart's economic situation in Vienna can to some extent be measured by the location and scale of the many residences he rented there. In January 1784, he moved to Tratnahov and in September of the same year, he moved to an apartment located in the city center, now Domgasse 5, near Stephansdom. However, by the middle of 1788, he moved to the distant suburb of Alsergren, where the rent was much cheaper. Mozart's main sources of income during his stay in Vienna included the profits from public concerts, the payments from private patrons, the money earned from teaching and publication fees, and the salary for serving as the Kammermusicus in the court from 1788 onwards. Mozart's early performances in Vienna were a good source of income. In 1784, he attracted more than 100 spectators to attend three concerts on Gurdon 6. Mozart toured concerts in Leipzig, Dresden, and Berlin in the spring of 1789. The details of the journey are very few. In Dresden, he played chamber music privately and performed at the court. In addition, he participated in an informal competition with organist J.W.Hässler. According to reports, in Leipzig, he improvised on the Thomas Kitcher organ, at which time J.F. Doles was a former student of Bach. Mozart might have sold some works in Potsdam and Berlin, and he also performed in *Die Entführung*.

In 1789, his main focus was on the creation of *Così fan tutte*, which was his third collaboration with DuPont. The lyrics may be entirely original, as the subject is sometimes claimed to have been proposed to Mozart and da Ponte by Joseph II himself, supposedly based on a recent real-life event. People know very little about this

opera. It was rehearsed at Mozart's home on December 31st, rehearsed at the theater on January 21st, 1790, and premiered on January 26th. The next four performances were suspended due to the death of Joseph II in February. With the accession of the new emperor Leopold II, Mozart hoped to be promoted in the court.

In September 1790, Mozart took his brother-in-law Franz de Paula Hofer and a servant to Frankfurt. They arrived on September 28th, and Mozart held a public concert on October 15th. Despite success in music, the audience was small and the economy was also a failure. On the return journey, Mozart held a concert in Mainz, listened to *Figaro* in Mannheim, and performed in front of the King of Naples in Munich. Around November 10, he returned home and lived with Constanze in a new apartment in the center of Vienna, where Constanze had just moved. In the winter months, he composed a piano concerto K.595 and the last two string quintets K.593 and K.614. He performed a concerto at a concert organized by clarinet player Josef Bähr, and performed an aria and a symphony at the Tonkünster Society concert in April. In the same month, Mozart obtained the important and paid position of Kapellmeister in Stephansdom from the city council, while Leopold Hofmann was elderly and sick at the time; He was appointed as an assistant and deputy without any salary, but ultimately Hoffman lived longer than him.

It was to celebrate the coronation ceremony of Leopold II in Prague that Mozart composed *La Clemenza di Tito*. Reports published shortly after his death indicate that the creations were only written for 18 days, some of which were written on long-distance buses between Vienna and Prague. On July 8th, manager Domenico Guardasoni signed a contract with Bohemian Manor, and his first choice for creating a coronation opera was Salieri. But Salieri refused the commission, and the work fell on Mozart. Mozart described Tito as "a Villa opera". The

premiere would be held on September 6th.

Mozart's works were widely published in 1791. In that year alone, Viennese publishers released nearly a dozen versions of Mozart's works, targeting audiences far beyond the court circle. These include the string quintets K.593 and K.614, Anton Stadler's concerto K.622, *Laut verkünde unsre Freude* K.623, and the aria *Per questa bella mano* K.612, K.626, *Ave verum music collection* K.618, *Die Zauberflöte* K.620 and *Requiem* K.624. As mentioned in a letter to Constantze, *Die Zauberfl* for Emmanuel Schikandel's suburban theater auf der Wieden was successfully completed on June 11th. In addition to the three vocal projects of overture and march, it may be completed in July. There are several sources for this opera, including Libeskin's *Lulu*, which was published in Verlander's collection of fairy tales *Dschinnistan* (1786—1789).

Despite the opera's popularity — a sentiment shared by contemporary music critics — some found the libretto unsatisfactory. The opera begins with a traditional story about a heroic prince (Tamino) who, under the command of his mother (Night Queen), rescues a beautiful princess (Pamina) from an evil kidnapper (Sarastro). However, in Orator's scenario, the kidnapper is benevolent and the evil one is the princess's mother. Tamino and Pamina are ideal beings seeking self-actualization.

Perhaps in mid-July, Mozart was commissioned by Count Wolfgang Stupach to compose a Requiem for his wife who passed away on February 14th, 1791. When Mozart fell ill for the last time, he only completed the Eternal Requiem; From *Kyrie* to *Confutatis*, only the vocal part and the continuous bass were fully written. In *Lacrimosa*, only the first eight bars were used for the vocal part, while the first two bars were used for the violin and viola. At the end of November, Mozart was bedridden. He was taken care of by two famous Viennese doctors, Closet and Sallaba. On December 3rd, his condition seemed to

improve, and the next day, his friends Schack, Hofer and bassist F.X. Gerl gathered to sing parts of the unfinished Requiem with him. However, that night, his condition worsened. He passed away before 1 am on December 5th.

On December 7th, according to the customs of contemporary Viennese people, Mozart was buried in an ordinary grave in the St. Marx's Cemetery outside the city. The day was calm and gentle, and the talented musician ended his glorious life.

/ Chapter II /

# Musical Analysis of *Exsultate Jubilate*

Mozart visited Milan, Italy for the third time in order to perform his last opera of his *Lucio Silla*. During this stay, he created the song *Exsultate Jubilate*, which is a suite of scriptures created by Mozart and one of his most famous religious vocal works. This work was premiered by the castrato singer Venanzio Rauzzini, who played Cecilio in *Lucio Sila*, at the Tiachino Church in Milan. As this work was written for singer Rauzzini, it can also be considered a tailor-made musical work, and the manuscript of the work is currently housed in the Berlin National Library.

Mozart, who stayed in Italy three times for a total of 22 months, traveled to most parts of Italy. Compared to when he was in Austria, Mozart created more so-called secular opera style church music during this time. In terms of this work, the only religious factor was the Latin lyrics, and all the other moving parts had the fun of opera. From the composition of the music, it can be seen that this work did not follow the form of the scripture song at that time. It was not composed of two arias and two recitatives, and ended with the form of *Hallelujah*. This work only has a recitative between the first and second movements. If this short and connected narrative tune is removed, the work forms a fast-slow-fast movement combination, which reflects the strong character of the prelude or vocal concerto in the opera at that time.

In a sense, this work cannot be simply summarized as an opera, because it is a solo and band work. Among all Mozart's solo and band works, the most famous is not a certain piece of music, but a hymn with three movements for soprano, band and organ, which is the best expression of Mozart's early vocal music style. The closing piece of the last movement, *Hallelujah*, became a classic piece of music at that time because of its unique style and lively rhythm, and has been maintained for more than 200 years.

This work can be divided into four parts, among which there are three movements with different personalities. The first part is the first movement *You Cheer and Cheer*, which is an allegro movement in F major. The second part is the recitative *Twinkle of Light in the Day*, which serves as a functional connection between the first and second movements. The third part is the second movement *The Coronation of the Virgin Mary*, which is a slow tempo movement with a tonality in A major. It is neither a dominant nor a subordinate key, but uses a refreshing third degree relationship in A major. The fourth part is the third movement *Hallelujah*, which is an allegro movement in F major. The overall composition is characterized by a fast, slow, and fast musical structure, which is more commonly found in large-scale vocal and instrumental concertos.

## 2.1 Harmony Analysis of *Exsultate Jubilate*

Mozart was one of the important composers of the Austrian classical music school in the eighteenth century. Looking back on his life, we can find that he had been devoted to the development and improvement of music creation. He was an all-round composer with endless creative inspiration. Since I came into contact with Mozart's vocal works, I have been attracted by his extremely beautiful melodies

and elegant lyrics. He often tailored his compositions based on the singer's tone and technique. This work is a so-called secular-leaning church music, which combines perfectly the two musical forms of opera and concerto, and its fast-slow-fast movement combinations have the characteristics of opera overtures or vocal concertos of the time. This work has a magnificent and smooth style, and uses a large number of floral phrases. It is a work between religion and secular, modeled after the secular church style of Italy at that time. Apart from Latin lyrics and the digital bass of the organ, there is almost no sound of religion.

### 2.1.1　Melody development characteristics

This work consists of three movements, each with a different theme. These themes control the development of music, making the music material highly concentrated. This shows the composer's creative ability, and from the development and changes of themes, we can also glimpse the composer's creative techniques.

2.1.1.1　Theme development of the first movement *Exsultate Jubilate*

In the first movement, the composer used a total of three themes, and the theme played by the viola at the beginning appeared magnificent and brilliant against the backdrop of the orchestra playing together. At the beginning, the melody jumps from the tonic to the lower fourth of the dominant note, followed by the upward movement of the scale, where a descending seventh level external note ♭E is used, and then falls on the lower middle note D. The development of the melody is arched, at which point the harmony enters the subordinate direction. In order to further develop the melody, the composer used a six-degree jump and emphasized repetition all the time. After the five-degree jump, the melody is still an arched development, except that the scale is preceded by an upward movement and followed by a decomposed

chord. Finally, the theme stops on the subordinate tone after encircling.

**Example 1**   *Exsultate Jubilate*

The development of the melody here is intriguing and possesses a distinct personality. The frequent large leaps in the melody echo the exuberance conveyed in the title of the music. The use of arched melody lines creates dynamic fluctuations reminiscent of flowing water, and the composer refrains from employing excessive chords. Only the three chords — tonic, subdominant, and dominant — are utilized to establish tonality. To further emphasize and solidify tonality, the composer employs dominant continuation in the first two phrases, enhancing clarity. The dominant chord undergoes transposition to its original position, while the other chords remain in their original positions.

The first theme of the first movement does not appear in the vocal part but only in the accompaniment throughout. The two oboes are linked by rapid sixteenth notes followed by ascending eighth notes, sustaining a cheerful and lively emotional atmosphere. After the soloist reintroduces the first theme, the second theme transitions to the dominant key for accompaniment. The third theme of the music emerges in the vocal section. While all constituent notes of the melody belong to the C major scale, the audience may not perceive this connection. The composer initiates the melody by descending from the tonic to the dominant, repeats it, executes a leap of a seventh, and finally descends back to the tonic.

**Example 2**   *Exsultate Jubilate*

At the beginning of the second presentation of the sub-theme, the composer used $K_4^6$ chord continuously here, so that the sense of termination of the music was reflected, and the melody of the music was repeated to strengthen it. The melody of the next human voice is a fast and continuous 16-point note. The melody of this section should be sung without interruption and completed in a single phrase.

2.1.1.2　Development of the theme of the second movement *Crowned Virgin Mary*

The second movement is not in a minor or subordinate key, but rather in A major, utilizing a relationship with the third degree. Both the emphasis on the first theme of the second phase and the parallel descent of the second theme are melodies with a strong folk flavor.

**Example 3**　*Tu Virginum Corona*

The first theme ascends from the tonic up five degrees to the dominant note, then descends to the tonic B before rising again. C and D form minor second intervals, and the addition of the third and fourth intervals adds more leaps to the melody. However, minor second intervals are still employed in the end. Similarly to the first theme, the second theme also employs a descending scale composition method. However, unlike the first theme, the second theme does not utilize a circuitous melody development; instead, it reverses the descent. The first descent is by three degrees, while the second descent is by five degrees.

2.1.1.3　Theme development of the third movement *Hallelujah*

The third movement is frequently performed separately by singers in

concerts, where the vowel (ah) is consistently utilized. Simultaneously, in the accompanying voice, the use of staccato is more fitting for the context of "dance, joy" in the lyrics.

**Example 4** *Alleluja*

The rapid-paced third double tone reflects the cheerful atmosphere of the music. The music begins with the fifth note of the main chord and then resolves to the fifth or sixth chord. The composer then employs the typical functional harmony logic I −(VI)− IV − V − I to clarify the musical style. Additionally, the use of staccato enhances the originally bright and cheerful melody, making it more magnificent and lively.

## 2.1.2 Application of Harmony Techniques

The functional system of major and minor, also known as tonal harmony or functional harmony, originated in the Middle Ages and Renaissance, took shape in the Baroque period, matured during the Classical period, and underwent further development during the Romantic period. The composition *Exsultate Jubilate* serves as a representative example of the major and minor harmony system.

The functional system of major and minor consists of specific chords and tonal sequences. The establishment of tonality within the functional system of major and minor, whether limited to a certain tonal sequence (using only natural sound systems) or incorporating variant sound systems, does not alter the establishment of tonality. Although the functional system of major and minor is connected to the tonal sequence, its core revolves mainly around the tonic and its derived major chords (major and minor triads), based on the relationship

between the fourth and fifth degrees.

The major and minor functional tuning systems exhibit various characteristics, which can be categorized into several aspects: Firstly, they are based on chords with a three-dimensional structure in the vertical direction, especially triads and seventh chords. The consonant major or minor triad typically serves as the focal point, which is generally fixed and unique. Secondly, they rely on modal tone sequences derived from natural major and harmonic minor scales, with other modal tone sequences supplementing the major and minor systems. Thirdly, the functions of tones and chords are divided into different levels, with their relationship primarily based on the fourth and fifth degree relationship, which holds a dominant position of control. Meanwhile, relationships based on the second and third degrees function in a supportive, dependent role.

2.1.2.1 Chord structure

In *Exsultate Jubilate*, the composer employed third-degree superimposed chord structures and utilized common chord progressions such as major triads, minor triads, and major and minor seventh chords within the classical harmony system. When selecting chords, the composer primarily utilized commonly used chords such as tonic, subdominant, and dominant chords.

To enhance the auditory appeal of the composition, the composer incorporated a plethora of non-diatonic chord tones, including auxiliary tones from the natural and chromatic systems, passing tones, appoggiaturas, anticipations, and suspensions. The utilization of these non-diatonic tones introduces dissonant elements into the composition, fostering constant development characterized by contradiction, conflict, tension, and eventual resolution.

2.1.2.2 Mode and Tonality

Except for the recitative *Twinkle of Light in the Day*, which

exclusively employs the key of D major, all three other movements undergo adjustments. In the recapitulation section of the first movement, to reintroduce the music to the main key and establish a "tonal return," the primary section transitions into a "false recapitulation" from the minor key of C major before returning to the "true recapitulation" in F major for the statement. In the initial eighty-four bars of the piece, instead of reverting to the main key of F major, it transitions into the relative minor key of ♭B minor, which is parallel to F major. The return to F major occurs only at the conclusion of this minor theme, serving a similar function of "false recapitulation." Subsequently, the music fully returns to the main key of F major for the presentation. This illustrates that the composer not only utilized the main key but also incorporated subordinate keys.

In the second movement, the composer begins in the main key of A major, then transitions to the minor key of E minor, after returning to A major, finally returns to the relative minor key of D minor. It is noteworthy that at the conclusion of the second movement, the composer alternates between major and minor keys using the same tonic, reducing the primary chord to a minor triad in A major and maintaining the same tonic in minor. Through this adjustment of the common chord, they establish a first-level relationship in A minor and initiate the third movement in F major.

The third movement exclusively employs the main key of F major and the minor, key of C minor. In the first interlude, the accompaniment of the 25th bar utilizes common chord tones of both F major and C minor, facilitating a smooth transition to the minor key of C major and further development upon entering the first interlude. In the second primary section, the composer employs the technique of modulation to enhance the chromaticism of the melody and texture. Subsequently, the composition quickly returns to the minor key of C major. Towards the

conclusion of the piece, the bassline continues to emphasize the repetition of the tonic F, reinforcing the tonality and providing a solid foundation for the recapitulation of the main section, ensuring a smooth return to the original mode.

2.1.2.3 Harmony, Rhythm and Texture

The general harmonic structure of the composition typically involves one chord per measure, contributing to a brisk pace and creating a rapid harmonic rhythm effect.

**Example 5** *Exsultate Jubilate*

Example 5 consists of the first four measures of the opening movement of the piece. The composer employs only three chords: tonic, subdominant, and dominant, aiming for greater stability in the bass while emphasizing tonality. In the first two measures, the composer uses pedal tones. This technique is extensively employed throughout the composition to reinforce the tonic. The functional logic of the chords here is tonic-subdominant-dominant-tonic, establishing the tonality from the outset. It's worth noting that when the composer uses the dominant chord, they start with the dominant triad before proceeding to the dominant seventh chord, intending to facilitate the motion of the bass voice by a second. This not only enhances the

melodic aspect of the bass but also breaks away from the monotony of only utilizing the tonic and dominant tones in the bass.

The piece predominantly utilizes chord progressions within the harmonic framework, comprising essentially four sections. Upon analysis, it becomes evident that it's essentially a structural composition amalgamating two-part and four-part forms. These four parts converge to form comprehensive chords and undergo coordinated development.

2.1.2.4 Harmonic Vocabulary

Regarding harmonic vocabulary, the composition predominantly employs standard progressions such as tonic-dominant ( I – V ), tonic-subdominant ( I – IV ), and deceptive cadence ( V – VI ), which align with the functional logic of classical harmony. However, the composer occasionally substitutes secondary chords for subdominant chords.

Another distinctive feature of the harmonic vocabulary is the utilization of chromatic chords. Predominantly, the composition employs heavy dominant chords, frequently preceding the cadential six-four chord, sometimes independently, before resolving to dominant chords. For instance, in the 27th bar of the first movement, the composer introduced a chromatic chord to complement the descending seventh note in the melody. Similarly, in the subsequent section at bar 44, the composer incorporated chromatic secondary chords. Although the use of chromatic chords throughout the composition is not extensive, they serve as embellishments. It is through the use of these chords that the degree of chromaticism and dissonance in the composition is heightened, achieving the desired effect of dramatic tension.

In addition to chromatic chords, another crucial aspect of harmonic vocabulary is the use of pedal tones. When employing pedal tones, the primary types are tonic pedal tones and dominant pedal tones. In this composition, tonic pedal tones are commonly used throughout, while dominant pedal tones appear exclusively in the third movement.

Beginning from the 102nd bar of the piece, to intensify the sense of conclusion, all chords here are resolved from the dominant seventh to the dominate chord. The consistent use of pedal tones in the bass section effectively heightens the sense of closure in the music.

*Exsultate Jubilate* exemplifies the elegant characteristics of Mozart's harmonic style through its clear harmonic structure, intricate harmonic texture, concise rhythmic patterns, refined harmonic vocabulary, and balanced contrasts. Mozart's harmonic style epitomizes the rational aesthetic principles of the Classical era, emphasizing the guiding influence of reason in composition and asserting that all artistic expressions must adhere to the aesthetic standards of elegance. A study of Mozart's harmony aids in a deeper comprehension of the overall style of his music and the overarching features of Classical music, which has considerable scholarly value.

## 2.2 Research on the Form Structure of *Exsultate Jubilate*

Throughout Mozart's musical career, the "sonata principle" served as the foundation for almost all musical forms and structures. While it imposes constraints on the design of individual movements, it does not dictate the overall composition. Typically, in such works, after the main theme concludes, the composition modulates from its primary key to other keys, often transitioning to the relative major or minor keys. Subsequently, thematic materials are introduced, with many or most of these motifs likely to recur within the movement. The music then returns to the tonic, creating structural tension by presenting the music in different keys. The entire piece features Latin lyrics and was originally composed to celebrate the birth of Jesus. Remarkably, Mozart completed the composition in a mere three weeks, showcasing his exceptional creative prowess and speed.

Chapter II  Musical Analysis of *Exsultate Jubilate*  091

This work is a small concerto for voice and orchestra, comprising three arias and a recitative. These movements are interconnected yet contrasted, contributing to a complete and diverse musical structure. Mozart created various musical atmospheres within this composition, ranging from relaxed and cheerful to solemn and dignified, gentle and sweet, and passionate and fervent. While each movement possesses its own unique personality, they are inseparable as a whole. The poetic direction of the piece is evident, transitioning gradually from realistic scenes to a celebration of the Lord. Particularly noteworthy is the final aria, *Hallelujah*, where the entire piece consists solely of the word "Allelujah." Its verse-like structure unfolds layer by layer, vividly expressing praise to the Lord. The musical structure of the composition largely adheres to the principles of classical music. The first movement, *You Cheer*, adopts sonata form composed of double exposition sections without a development section. The second movement, *Coronation of the Virgin Mary*, adopts a sonata form with double exposition sections and lacks a development section. Finally, the third movement, *Hallelujah*, is structured as a rondo form, which will be analyzed in detail below.

### 2.2.1 Analysis of the Musical Structure of the First Movement *Exsultate Jubilate*

The first movement of the composition follows a sonata form composed of double exposition sections, characterized by the absence of a development section. In this Allegro-paced movement, Mozart adopts the structure commonly found in Italian instrumental concertos of the time. Such an Allegro double exposition structure was typically employed in the first movements of Classical period concertos. The main theme of the movement is brief yet exhilarating. The orchestra introduces the main motif with vigor, descending to the dominant note

before ascending the scale. This section is brilliantly written and exhibits a concerto-style flourish. Typically, in concertos, the first exposition is performed by the orchestra, while the second exposition is taken up by a solo instrument. This approach not only reinforces the audience's familiarity with the melody but also elevates the thematic material of the composition.

The first movement consists of 129 bars in total, structured with double expositions, a recapitulation, and a coda, all in the key of F major. The schematic diagram of the musical structure is shown in Table 1.

Table 1  The musical structure of the first movement *Exsultate Jubilate*

| First exposition | Second exposition | Recapitulation | Epilogue |
| --- | --- | --- | --- |
| Bars 1 – 20 | Bars 21 – 70 | Bars 71 – 120 | Bars 120 – 129 |
| F | F – C | C – $\flat$B – F | F |

From the musical structure diagram, we can observe that Mozart largely followed the structure of the prelude of Italian opera of that era, omitting the development section. In terms of musical style, this composition not only showcases Mozart's command and evolution of classical musical forms and styles but also demonstrates his assimilation and fusion of various musical genres and styles. In this work, he employed a variety of embellishments, variations, imitation, counterpoint, and other techniques, ensuring that his melodies are not only beautiful and seamless but also expressive and imaginative.

The structure of a song is closely related to its lyrics and, at a macro level, typically consists of two main parts. Structurally, it

resembles a sonata form with two sub-parts and lacks a development section. The presentation part introduces a straightforward narrative, while the recapitulation part reiterates the same lyrical content. In terms of musical treatment, this is manifested through alterations in tonality, shifts in melodic direction, and embellishments added to emphasize important syllables, all aimed at fully conveying the lyrical content.

The initial presentation section of the music is performed by the ensemble, presenting a developmental statement in F major. The musical structure comprises the main theme (bars 1-7), a transitional section (bars 8 - 10), a subsidiary theme (bars 11 - 18), and a concluding passage (bars 19 - 20). The ensemble's performance establishes the foundational musical style of the entire composition, characterized by a distinct tonality. Beginning in F major, the first ten bars feature a mixed texture primarily involving strings, culminating in a cadential chord structure with a semicadence. Bars 11 through 20 constitute the subsequent section, where the primary timbral technique involves alternating between the string orchestra and the oboe. The character of this section differs significantly from the preceding material, ultimately resolving on the tonic chord. The overall atmosphere is light and transparent, with frequent use of syncopated rhythms, showcasing Mozart's characteristic smoothness in musical expression. It is noteworthy that the composer incorporates octave tremolos and rapid sixteenth-note homophonic repetitions in the accompaniment, further enhancing the characteristic qualities of the title "cheering".

The second section features a soloist and holds significant importance in this movement. It can be segmented into three parts: the main theme (bars 21 - 33), the transitional passage (bars 34 - 47), and the subsidiary theme (bars 48 - 70). The introduction of the human voice resembles the entrance of a sage figure, transforming the initially

spirited and lively music into a smooth and solemn vocalization. However, rather than imparting a sense of melancholy, it exudes a bright, splendid, noble, and elegant musical style. The lyrics roughly convey "Exsultate, jubilate, o vos animae beatae", structured in 6+7 sentences. The initial six bars of the melody are predominantly characterized by leaps, gradually transitioning towards a more progressive form, presenting an overall "plain" texture. The final seven bars of the section commence with a markedly subdued and transient modulation to the subdominant key of B major, seemingly employing a technique of "restraint before ascension". Subsequently, the music returns to the original key with an extended range, transitioning to eighth notes, and culminating with a reiterated emphasis on "cheering and leaping with joy". The completeness of this passage is underscored by a conclusive cadence in F major in bars 32 to 33. Material fragments from the initial presentation section (bars 19 – 20) are reprised in subsequent bars 34 and 35, serving not only to supplement the main section but also to facilitate a smooth transition to the subsidiary section.

The transitional section comprises three phrases (4 + 4 + 4), featuring a tonal progression of F – C – C, with bar 47 concluding on the chords of C major. Structurally, it constitutes an open-form musical segment, in terms of musical expression content, it means that the next paragraph will be a further musical expression of the lyric content described in paragraph B. The central theme of the lyrics (with a comma as a point), "dulcia cantica canendo, cantui vestro resposdendo, psallant aethera cum me" there exists a distinct juxtaposition between the lyrical phrases and musical phrases, possibly indicating a deliberate separation to accommodate the demands of the musical structure or to enhance the sense of open-endedness inherent in each lyrical utterance. This approach underscores the singer's emphasis on maintaining the coherence of the musical narrative. The musical imagery in this section

evokes the essence of religious music while also embodying a fusion of secular and sacred musical elements. The modulation from F major to C major in this segment imbues the music with a heightened sense of lyricism, further enhancing the joyful character of the composition.

The lyrics of the subsidiary theme remain unchanged from before, yet the musical character undergoes a transformation. The primary focus is on the main thematic material, with localized polyphonic elements providing accompaniment. This section predominantly employs polyphonic techniques, with the incorporation of musical material from the preceding presentation sections in bar 48, resulting in a somewhat whimsical effect. As such, the melody appears as a counterpoint to the ensemble part, demanding the singer's careful attention to the ensemble's contribution. Structurally, this segment adopts a non-square, sectional structure (4+14), with an overarching tonality of C major. The second sentence repeats the initial line of the lyrics and extends the vocal range by four bars, employing a "melismatic" technique towards the end of bar 56. Following a significant interval leap, the composition reaches its first climax in bars 60 – 65, accompanied by the ensemble for a few additional bars. Subsequent to the climactic section, the music gradually subsides, leading into the recapitulation section.

As this movement lacks a development section, what ensues is not a conventional recapitulation. Its purpose is to reintroduce the music to the main key and establish a "tonal return". Contrasting with the presentation section, the primary section shifts from C major to a "false recapitulation" before reverting to the "true recapitulation" in F major for the statement. At the onset of the eighty-fourth bar, instead of directly returning to F major, the music transitions to the minor key of B major within F major. Only at the conclusion of the subsidiary theme, which also holds significance as a false recapitulation, does it

ultimately revert to F major; thereafter, the music thoroughly returns to the main key F major for the presentation, all of which adhere to the principle of sonata form (tonal regression) in structuring the musical composition. Besides the tonal shift, there is a modification in the local pitch material, while the musical structure remains unchanged, maintaining the (6 + 7) section structure. The inclusion of the subsequent two bars also serves a transitional role. In this segment, the structure undergoes a "deformed" alteration from the previous one, with the presentation section (4+4+4) evolving into a (4+4+14) configuration. Mozart employs the creative technique of "melisma" in the preceding section, expanding from 4 bars to 9 bars. The embellished adornment of the "E" section significantly enhances the expressive capacity of the music, infusing the melody with heightened vitality. Consequently, the accuracy of pitch, consistency of tonal placement, and management of micro-breathing may present certain challenges for vocalists. Subsequently, the overall tonality of the music reverts to F major, mirroring the principle of sonata form. The phrasing appears more "focused" compared to earlier, with the second sentence reducing the number of "melismatic" notes and ultimately resolving on the tonic in the 119th bar. Following two measures of band preparation, measure 122 marks the final rendition of "Reciting Hymns in Space".

At the culmination of the final 19 bars of the music, a vibrant orchestral interlude emerges at bar 123, providing a space for the singer's instrumental solo. This colorful segment follows the resolution of the cadential chords and concludes the movement once the singer completes the solo. This segment is intended to echo the thematic material introduced in the first presentation, thereby bringing the entire piece to a close.

The overall style of the first movement can be characterized as splendid. The graceful and reverent vocal passages harmonize seamlessly

with the exuberant and lively accompaniment. This amalgamation of elements appears to be harmonious instead of abrupt, reflecting Mozart's adeptness at integrating religious and secular musical influences in his compositions.

### 2.2.2 Analysis of the Musical Structure of the Recitative *Twinkling Light in the Day*

In addition to conveying the lyrical content, the aria emphasizes the expressive capabilities of the melodic lines. The recitative prioritizes the rhythmic cadence of the language's syllables, akin to a "recitation" style. Regarding the musical texture, the aria exhibits a diverse texture intricately tied to the melodic rhythm. Conversely, the recitative typically employ a straightforward chordal accompaniment to provide a foundational backdrop for the singer's delivery.

The recitative *Twinkling Light in the Day* serves as a bridge between the first and second movements, accompanied by an organ in D major. In a recitative, the melody takes a back seat to the singer's spoken delivery. This prioritization is necessary to ensure clear comprehension of the lyrics by the audience, while simultaneously highlighting the expressive content of the text, thereby intensifying the dramatic tension in the music. It is essential for the singer to not only be well-acquainted with the lyrics but also to deliver them with a devout tone, akin to a prayer to God. Consequently, the musical style of this passage starkly contrasts with that of the first movement, while also setting the stage for the ensuing slow movement.

This musical segment spans twelve bars, representing a harmonious essence in musical composition. The rhythm, influenced by the inherent rhythm of the language, fluctuates between tight and loose. Internal tonal shifts to the IV and II chords enrich the music with color and depth. The melody structure in the initial section features broken chords,

conveying a sense of unwavering belief. Notably, the downward leap of a perfect fifth adheres to the natural attraction of the temporary dominant (V) to the tonic (I) within the harmonic series. Singers must express this natural melodic inclination while maintaining seamless breath control, avoiding any discernible transitions. The transition between the first and second bars involves a two-step ascending scale, offering smoother continuity compared to the preceding leap. However, attention to pitch performance remains crucial during this temporary relaxation in vocal technique. This rhythmic progression of leaps and advancements persists throughout the piece, evoking varied emotional responses from the singer.

### 2.2.3 Analysis of the Structure of the Second Movement *Coronation of the Virgin Mary*

The development of Western music is intricately intertwined with religious influence. The central theme of this piece revolves around the invocation, "Tu virginum corona, tu nobis pacem dona, tu consolare affectus, unde suspirat cor." This can be interpreted as both a prayer to the Virgin Mary and a profound ode to her love. Similar to the preceding movement, this piece begins with an extended orchestral prelude, where the melodic motifs of the vocal section are introduced. Notably, the orchestration comprises solely string instruments and natural horns, with the absence of woodwinds, lending it a somewhat subdued quality. However, this austere instrumentation aligns with the thematic essence implied by the title. Structurally, while adhering to the overarching principles of a sonata, it deviates from a conventional sonata form. The initial section consists of two subsections, with the first serving as a straightforward expression of the lyrics without significant emphasis. The subsequent section extends and elaborates upon the initial thematic material, with a heightened focus on the local

tonal nuances emphasized in the latter half of the lyrics. The second part comprises two identical sections. The initial section mirrors the preceding one, characterized by a smoother tone and heightened emotional depth. Apart from certain extensions and variations, the latter portion of the segment reintroduces a contrast with the first part, aiming to intensify the expression of praise for the Virgin Mary.

The second movement maintains a slow tempo, spanning a total of 115 bars. It is composed in the key of A major and adheres to a sonata form composed of double exposition sections without a development section. It encompasses the first exposition, the second exposition, a recapitulation, and a epilogue. The primary distinction between this movement and the first lies in their respective tempos. The melody throughout the movement is lyrical and gentle, establishing a continuity with the recitative of the preceding section. Additionally, it necessitates a prayer-like delivery. The structural outline of the musical form is depicted as follows:

Table 2 The musical structure of the second movement *Exsultate Jubilate*

| First exposition | Second exposition | Recapitulation | Epilogue |
| --- | --- | --- | --- |
| Bars 1 – 22 | Bars 23 – 66 | Bars 67 – 101 | Bars 102 – 115 |
| A | A – E | A – D – A | A |

From the structural diagram of the musical form, it is evident that the composer employed a similar structural framework as that of the first movement, incorporating a sonata form composed of a double exposition sections without a development section.

In the first exposition, the music unfolds in A major. There is a

lack of pronounced contrast within the music, and the entire section exudes a tranquil and solemn musical style. The instrumentation predominantly comprises string ensembles, with intermittent utilization of natural horns. The structure comprises four phrases (4+4+4+6), with the first phrase establishing the tonal foundation of the thematic material, situated within the mid-range; The second phrase introduces a micro-motivic statement in an "echoic" manner, pitched higher than the preceding phrase, thereby carrying transitional significance; The third phrase, characterized by the resonant timbre of a cello, delves into deeper musical textures. Following the introduction of sixteenth note embellishments, the rhythmic complexity deepens with a subtle fluidity; The fourth melody, performed by the violin, unfolds in synchronized harmony, evoking a sense of solemnity and sanctity. For vocalists, a thorough comprehension of the orchestra's expressive capabilities can facilitate a more nuanced interpretation of the composition.

The second exposition commences with a solo passage identical to that of the first movement, distinguished primarily by its tonality. Here, it begins in A major, shifts to E major at the 33rd bar, leading directly to the thematic material of the subsequent subsection at the 40th bar. As it progresses through intervals and transitions, the initial phrase establishes a progressive relationship, with subsequent microstructures maintaining consistent or secondary-degree relationships, imparting a sense of solemnity and sanctity with minimal fluctuation. Following the repetition of the first phrase's material, subtle alterations are introduced in the second phrase, culminating in an open cadence at its conclusion, resolving to the dominant chord in A major. It is imperative for the singer to execute the musical passages seamlessly, ensuring continuity throughout. Additionally, this cadence serves as the focal point for the subsequent section, facilitating a smoother transition between the two segments.

Although the subsection within the second exposition employs the same lyrics, it contrasts with the main section in terms of musical expression. The initial verse spans six bars, retaining consistency with the first verse of the main section but altering the tonality to E major. The melody undergoes changes in shape, featuring more interval leaps and an overall upward shift in vocal range. Consequently, there is an escalation in musical tension, enhancing expressiveness. As the second phrase unfolds, the tonality remains E major, accompanied by a continued ascent in the overall vocal range and changes in texture. The addition of embellishments, such as sixteenth note ornamentations, imbues the music with dynamism, extending the length to 14 bars akin to the first aria. However, there is an absence of "melisma" or excessive ornamentation to preserve the integrity of the composition's thematic essence. A more accurate rendition can be achieved by interpreting it within the context of recitation. In poetry recitation, words with mood patterns are often reiterated, and locally significant gerunds are repeated to fully convey the profound meaning concealed within the verse. The subsequent transitional passages (bars 54 – 60) hold transitional significance. The thematic material of the concluding phrase is juxtaposed with the opening, suggesting an inverted reproduction. The second phrase mirrors the structure of the preceding section's second sentence. Emerging from a subordinate chord, it carries a degree of instability, Ultimately, delivered in a questioning tone. the second phrase seamlessly reverts to the initial melodic form.

The recapitulation reverts to the main key of A major, where the musical theme is faithfully reproduced from the exposition section. However, following the initial presentation of the theme, the music swiftly modulates to the subordinate key of D major, imbuing the tonal palette with a somber hue. The introduction of the seventh-degree melodic interval initially elevates the musical tension to a zenith,

intensifying the overall mood. Subsequently, the concealed voices gradually descend, culminating in a cadence on the semi-terminating chords, establishing a temporary stability. The second phrase employs similar expression techniques to those utilized in the exposition, featuring the repetition of key emotive particles and predicate-object structures. Particularly challenging for the vocalist is the ascent to the high pitch zone, commencing at the 85th bar, which requires considerable vocal prowess. The third verse extends to 17 bars, maintaining the same lyrics as the second verse. The musical structure further expands upon the initial thematic material, aligning with the earlier notion of exaggerated expression. It is noteworthy that the inception of the thematic material in the subsection mirrors the reproduction of the first exposition, albeit incompletely, focusing solely on reproducing the preceding rhythmic patterns.

Similar to the first movement, the conclusion of this movement features a splendidly vibrant segment. Although this colorful segment comprises only two sections, it provides ample opportunity for the vocalist to showcase their abilities. Following the colorful segment, a ten-section musical passage not only serves as the culmination of the movement but also serves as a transition to the third movement, *Hallelujah*. The musical material in this passage resonates with the main theme throughout, thus harmonizing the structure of the movement. Ultimately, the music concludes on the seventh chord in F major, seamlessly leading into the subsequent movement and eliminating any sense of abruptness between movements.

### 2.2.4 Analysis of the musical structure of the third movement *Hallelujah*

"Hallelujah" originates from the Old Testament Psalms as a Hebrew praise to God. This aria centers solely on the word "Hallelujah,"

gradually unfolding in its repetition. For composers, this presents a challenging task in creativity. For singers, a precise analysis of the musical structure directly impacts the ability to express various nuances of the music systematically. The composition principle of this piece aligns with the rondo form.

This movement stands out as the most renowned piece within the entire composition, holding a significant place in the evolution of vocal music. Its musical expression not only mirrors Mozart's reverence and admiration for religious motifs but also encapsulates his love and jubilation for life and art. Many coloratura sopranos incorporate this piece as the finale of their concerts. Spanning a total of 159 bars, the music is typically performed seamlessly following the previous movement, albeit in sharp contrast in terms of tempo. It resembles a celebratory carnival following a prayerful gathering in church, perfectly encapsulating the theme of *Exsultate Jubilate*. This movement also pushes the emotion of the whole song to its peak. The structural diagram of the music form is as follows:

Table 3　The musical structure of the third movement *Exsultate Jubilate*

| Introduction | First main part A | First insertion part B | Second main part A' |
|---|---|---|---|
| Bars 1 – 8 | Bars 9 – 24 | Bars 25 – 59 | Bars 60 – 85 |
| F | | C | C – F – C |
| Second insertion part C | Connecting part | Third main part A" | Epilogue |
| Bars 86 – 118 | Bars 119 – 126 | Bars 127 – 154 | Bars 155 – 159 |
| Cmurf | F | | |

The eight-bar introduction is performed by the orchestra, establishing the musical foundation for the subsequent thematic development. The core theme of the entire piece is formed by two echoing sentences. The progressive melody imbues the music with a smooth and sweet quality, portraying an inner sense of praise for Jesus. Additionally, the tonality returns to the main key of F major, consistent with the tonal center of the first movement.

The first main section, denoted as A, features vocal singing and comprises two extended phrases, each containing two shorter phrases, thus constructing a complex sectional structure. Building upon the preceding introduction, this section aims to accentuate the thematic essence. The second extended phrase introduces a local variation in its latter half, momentarily shifting to a subordinate key before resolving unexpectedly, thereby creating a contrast with the preceding phrase. The singer should be attentive to the subtle shifts in musical mood before returning to a state of stability.

The first insert, denoted as B, enters the major C of the main key, forming an extremely unbalanced contrast in length with the more indicative paragraph A and bearing significant developmental significance. This specific structure comprises four parts. Bars 25 – 32 serve as the presentation of the material, characterized by dissonant intervals in the melodic form, broken chord progressions in octagonal rhythm, and continuous harmonic alternations. Ultimately, it concludes with an open ending chord, contrasting starkly with the preceding A section. Compared to the first part, the musical material in the 33rd bar holds greater developmental significance, originating from the material introduced in the 25th bar, with the orchestra's texture featuring a rhythmic interplay of sixteenth notes in a concealed voice in the second section. Emotions escalate further as the music progresses into the 37th bar, culminating in a complete termination. Bars 41 – 48 comprise a

repetition of the preceding material, aimed at emphasizing the musical personality of the preceding phrase and indicating forthcoming variations. In terms of musical intensity, there is a slight decrease compared to the preceding phrase, creating a notable contrast upon repetition. Bars 49 - 59 mark the climax of the overall B section, commencing with a temporary return to the main key of F major and concluding with a full stop in C major. The melody incorporates elements of "melisma style" and octave jumps, contributing to a rapid increase in musical tension and heightened expression.

The second main section, denoted as A', reproduces the first main theme but not in its entirety. The original vocal part is substituted by the band's accompaniment, employing a local echoing technique and establishing a question-and-answer format alternating between the band and vocals. The embellishment of the singing part in the second phrase undergoes expansion and modification. Initially, the "melisma style" decorates the "Ya" of "Hallelujah." Following the melody, it gradually transitions into higher notes, swiftly evolving from a sixteenth note rhythm to a quarter note rhythm, exuding strength and authority. The tonality here continues to develop in C major and has yet to return to the main key of F major, thus this segment lacks a sense of conclusion.

The lyrics of the second episode, denoted as C, are exceedingly simple, featuring only the single character "a" throughout the entire section. This portion is entrusted to the band to sustain the performance, a common technique in aria compositions. The band's role is to prolong the climactic stage of the singer, preventing an abrupt cessation and further amplifying the essential tension of the music. Despite the simplicity of the lyrics, they encapsulate the singer's devout heart towards God. Subsequently, the tonality of the music returns to F major.

Although the connecting section comprises only eight brief segments, its function is to bridge the preceding and subsequent

sections. Despite entering the main key tonality, termination is not achieved here. This segment is termed a "false recapitulation" within the musical structure.

The structure of the third main section, denoted as A, aligns entirely with that of the first main section A, serving as the genuine reproduction section. The distinction lies in the initial phrase, where the band leads for the first four bars before the vocals join. The subsequent phrase is entirely entrusted to the band, with an expanded overall sound range. Thus, the temporary absence of the vocal part aims to offer a final release of praise for Jesus. The ensuing segment features a higher sound range compared to the preceding paragraph, creating a contrast without additional exaggerated changes. As the homogeneous material of the latter phrase unfolds, it transitions into a syllabic rhythm in the 147th bar, characterized by greater pitch fluctuation, effectively culminating in the complete release of praise for Jesus.

The ending of the entire piece comprises only five bars. It features multiple repetitions of the main chord, maintaining the sense of "unfinished" from the preceding singing section, ultimately concluding with a complete repetition of the main chord.

Religious songs typically exhibit a slow and lengthy characteristic. However, in this composition, Mozart merges religious and secular music, conveying loyalty and piety to God through cheerful and lucid musical language.

## 2.3 The Characteristics of Mozart's Creative Techniques

As an important composer of the Classical period, Mozart's music style is characterized by simplicity yet magnificence, and his creative output encompasses diverse fields, including symphony, chamber music, and opera, holding significant positions in the development of

Western music history. Overall, Mozart's music features beautiful and dramatic melodies. The polyphonic interplay between voices is both vertical and horizontal, creating overlapping undulations. While the harmony adheres to a functional system, rhythmic changes infuse the musical textures with vibrant colors. The orchestration is remarkably adept, seamlessly blending with the imagery it evokes. Particularly noteworthy within his vocal works (including those with instrumental accompaniment) are his religious sacred solo songs.

As a pivotal figure in classical music, Mozart played a significant role in the development of European music. Throughout his lifetime, Mozart composed a total of 22 operas, 49 symphonies, 42 concertos, a Requiem, as well as hundreds of sonatas, chamber music pieces, religious compositions, and songs. Opera stood as the cornerstone of Mozart's oeuvre, and alongside Gluck, Wagner, and Verdi, he is celebrated as one of the four giants in the history of European opera. In the realm of symphonies, Mozart, in collaboration with Beethoven and Haydn, made profound contributions to European music history, penning some of its most illustrious chapters. Mozart also pioneered the piano concerto form, making remarkable strides in the advancement of European instrumental concertos. Additionally, his *Requiem* stands as a rare masterpiece in religious music. As a prominent European composer of the late 18th century, Mozart's music profoundly echoed the spirit of his era, particularly embodying the ideals of civil society. His operas held significant progressive significance for their time, marrying enchanting melodies with profound themes, often reflecting the plight of intellectuals in Mozart's contemporary society.

### 2.3.1 Breaking Conventions and Departing from Traditional Forms

In the 18th century, Europe emerged as a vibrant cultural nexus,

witnessing significant advancements across various domains. With the ascendance of the aristocratic class, classical music reached unprecedented heights. The advancements in commerce, technology, and transportation, coupled with the enlightenment of societal thinking and the pursuit of human emancipation, profoundly influenced Mozart's life, shaping his ideological concepts and creative style. During this epoch, instrumental music progressively supplanted religious chants as the predominant form. Genres expanded beyond the confines of religion and biblical narratives, encompassing themes drawn from nature, history, characters, and events, gradually emerging as popular creative elements. Mozart, an 18th-century Freemason, infused his music with human emotions and natural elements, characterized by purity and clarity devoid of impurities. He espoused the belief in the dichotomy of good versus evil, advocating for love, peace, and justice as the world's yearning and aspiration. In an era marked by burgeoning intellectual openness, these trailblazers challenged the strictures imposed by the church and feudal society, engendering an atmosphere of opposition. Mozart, in his own distinctive manner, reflected these sentiments through his music. Eschewing contact with the hypocritical adherents of the church, he followed his heart and composed freely. In the late 18th and early 19th centuries, the influence of non-traditional Christian denominations surged, elevating hymns to a status equal to that of the primary musical component of church worship. Simultaneously, in Catholic territories, the political ascendancy of the anti-Reformation movement and the reinforcement of religious orthodoxy spurred debates concerning the tangible and conceptual aspects of sacred music. Despite Mozart's burgeoning renown in opera and instrumental compositions, he found himself embroiled in increasingly heated debates. Generally, mastery of religious music is challenging, yet Mozart's religious compositions transcended strict adherence to traditional techniques of yore,

incorporating elements of secular music that were gaining popularity at the time. Mozart created a total of 600 musical works throughout his lifetime, with religious music comprising one-third of his oeuvre, including nine cantatas, seventeen church sonatas, twenty masses, among others. This significantly underscores his contribution to religious music. His religious compositions not only embraced tradition but also forged his distinct creative style through continuous exploration. In his vocal compositions, Mozart aimed to eschew the rigidity and incomprehensibility often associated with traditional church music. Instead, he fused simple, easily understandable lyrics with beautiful, majestic music and clear musical textures, thus establishing a unique style within religious music. Some have even asserted that Mozart's religious music rivals secular songs, even operatic arias in its appeal. One of the most notable examples is *Exsultate Jubilate*.

*Exsultate Jubilate* is a composition that merges elements from the Lyonnais and sonata forms found in Baroque opera arias. It exudes boldness and innovation, characterized by beautiful and fluid musical melodies, clear and distinct harmonic textures, as well as concise and lively lyrics that strike a chord with listeners. The melodic lines of this sacred song are both clear and tension-filled, setting it apart from many other religious works. *Exsultate Jubilate* is widely recognized as a sacred song. Its origins trace back to the 12th century with the Olmutz Manuscript, and in the early 13th century, the addition of upper voices, initially without lyrics, were added lyrics and gradually gave rise to this style of sacred song. Initially, only one or two upper voices were assigned Latin lyrics to sacred songs. However, in the mid-13th century, French lyrics began to emerge, and composers started to emphasize the double and triple sacred song forms. The musical form tended towards greater freedom and progressively incorporated secular

elements in later stages. By the 17th century, the sacred song genre experienced a loss of stability, with many composers blending the composition of sacred songs with concertos, arias, and other forms. *Exsultate Jubilate* can be viewed as a representative work of this "blend," with its musical structure combining elements of vocal and instrumental concertos.

As a prominent figure in the Viennese classical music scene, Mozart's works exhibit typical characteristics of the classical genre. *Exsultate Jubilate* stands as an opera from the middle of Mozart's prolific career. Influenced by the Enlightenment, this work seamlessly marries the opulent style influenced by Venetian music of the early period with a natural return to emotional expression. *Exsultate Jubilate* employs numerous extended musical phrases, characterized by clear and lively melodic lines. The primary melody of the upper register is complemented by harmonic accompaniment, forming a musical structure consisting of phrases ranging from two to four bars.

The composition incorporates a multitude of embellishments, enhancing the beauty and interest of the melody while imbuing the connections between notes with liveliness and charm. According to music history, early singers of Gregorian chant often introduced their own embellishments to the original melody. In the 16th century, performers frequently inserted brief ornamental notes into their music, thereby engaging in improvisation (free embellishment). During this period, soloists seldom adhered strictly to the score. Although initially confined to keyboard music, the practice of employing specific symbols to denote embellishments gradually emerged. As free embellishment assumed a greater role in musical performance from the 17th to the 18th century, a system gradually developed whereby embellishments designated by specific symbols were established. However, due to the idiosyncratic nature of early ornamental notation and the lack of

standardized conventions, correctly interpreting embellishment symbols posed a significant challenge. The same embellishment sometimes bore different symbols and names, while different embellishments were occasionally represented by the same symbol. It was not until Gluck (1714—1787) that composers began to exert greater control over grace notes in musical notation. They endeavored to clearly indicate the desired manner of embellishment in the score, employing simplified symbols to represent the most complex ornamental passages. Henceforth, the execution of embellishments ceased to pose a major challenge, leading to the establishment of standard embellishment practices ( essential embellishment). By Mozart's era, the conventions surrounding the use of embellishments had become well-defined and transparent. Mozart employed a plethora of embellishments, particularly in his piano compositions. He believed that every adept and expressive performer must imbue their interpretation with individuality and technical prowess. Consequently, performers were encouraged to introduce their own variations and characteristics into their renditions or utilize embellishments to convey their personal interests and viewpoints. Mozart's approach to embellishments was characterized by a sense of freedom, underscoring the importance of adhering to fundamental principles while deploying appropriate embellishments at opportune moments or notes. In Mozart's works, the most prevalent embellishment symbols include small notes denoting appoggiaturas, symbols representing trills, and tremolo symbols, all of which serve to enhance musical coherence and accentuate gradual changes in intensity.

### 2.3.2 Integrating Creative Elements from Other Musicians

Later generations have come to believe that Mozart's music embodies a synthesis of styles from various countries. Owing to his extensive travels and studies throughout Europe, he developed a diverse

range of creative styles. In addition to the guidance provided by his father Leopold, one can trace the origins of Mozart's style and identify various influences that shaped his artistic development. Since childhood, Mozart's studies took him far and wide, allowing him to absorb diverse musical traditions and techniques.

2.3.2.1 Johann Schobert's Influence on Mozart's Musical Style

During his time in Paris, young Mozart developed a keen interest in Johann Schobert's musical style and incorporated some of his creative techniques into certain sonata works. Schobert's harpsichord compositions employ rapid melodic passages and intricate chord progressions to emulate the richness of orchestral music. This approach is notably evident in Mozart's composition *Exsultate Jubilate*. Mozart also adeptly utilized this technique to achieve compelling accompaniment effects. Some researchers argue that Mozart's acquisition and refinement of an elegant and poetic style would not have been possible without the influence of Schobert's works.

2.3.2.2 Johann Sebastian Bach's Influence on Mozart's Musical Style

During his time in London, Mozart encountered Johann Sebastian Bach, whose profound influence greatly shaped Mozart's later creative style. Together, they explored various genres of composition, with Bach assimilating elements of Italian opera to enrich their own creations. Bach was known for incorporating movements from secular musical works, originally composed to honor kings, into religious compositions praising God — a practice that deeply inspired Mozart. In 1772, Mozart adapted three of Bach's sonatas into a piano concerto (K.107.1 − 3). Additionally, he pursued studies in counterpoint under Father Giovanni Battista Martini in Bologna. The influence of Martini and other Italian composers can be discerned in Mozart's symphonies composed between 1770 and 1773.

### 2.3.2.3 Joseph Haydn's Influence on Mozart's Musical Style

In the summer of 1773, Mozart once again encountered the music of Joseph Haydn in Vienna, and Haydn's influence on Mozart's compositions became increasingly significant. Mozart emulated Haydn's style and crafted symphonies K.183 and K.201, infusing them with his own creative flair to render these two works truly distinctive. Among these, K. 183 is also referred to as the "G minor" symphony. Renowned for its profound seriousness and thematic unity, coupled with Mozart's expansion of the symphony's overall form, this work garnered considerable attention. Prior to composing the sacred song *Exsultate Jubilate*, Mozart underwent several crucial stages of artistic development. He skillfully integrated his own creative style while incorporating elements from other composers. These transformations are not only evident in his compositions but also ingrained within his artistic sensibilities. His works serve as a mirror, reflecting the entirety of the musical era, resulting in a style that is not merely eclectic but transformative, giving rise to a new musical idiom.

### 2.3.3 Unique Creative Technique: "Mozart Style"

There exists a consensus in cultural history regarding Mozart's music and opera as products of the European Enlightenment movement. The Enlightenment movement, a multifaceted intellectual endeavor, elicits varying interpretations among scholars regarding its defining characteristics. Furthermore, akin to thinkers of other epochs, many concerns of Enlightenment philosophers find limited expression through music or drama. Empiricism, deism, and anti-authoritarianism, while pivotal to Enlightenment discourse, do not readily lend themselves to musical representation. Nonetheless, many foundational concepts and moral principles of the Enlightenment find resonance in music, particularly in the hands of great composers who espoused

Enlightenment ideals. Mozart unequivocally emerges as a composer with a profound grasp of these values. Like philosophers, Mozart contended that the potency of our inner thoughts and emotions transcends mere confrontation, thereby shaping his distinctive personal style.

In Mozart's early work, *Symphony in E-flat Major* (K.16), it is evident that the second movement, in the relative minor, features repeated triplets and contrasting melodic lines, serving as an early demonstration of Mozart's remarkable proficiency in composing slow movements. His precocious talent is apparent in the colorful and dynamic texture he creates in measures 29 – 32. Furthermore, the final movement, with its diverse emotional range, also showcases his strong creative abilities. During the period from August to September 1764, Mozart dedicated considerable time to composition, engaging in numerous experiments with counterpoint, as well as combining harmony and rhythm exercises, demonstrating his penchant for endless exploration. He compiled a small booklet titled "London Songs Collection" for jotting down ideas and interests as they occurred to him. Within this collection, there is a piece in G minor (ACM 36; K.15p), which later played a significant role in Mozart's tonal palette and expressive range in his creative endeavors. The structure of this piece follows a balanced bipartite form, suitable for serving as the final movement of a sonata or symphony, with repetitions or vibrato types offering distinct advantages, hinting at its potential for orchestration and incorporation into larger compositions. However, even within this structured framework, young Mozart endeavors to introduce maximum asymmetry. For instance, the five-bar unit at the beginning is omitted upon repetition, while in the latter half of the movement, a five-bar phrase is balanced against a four-bar phrase. Additionally, at the conclusion of each section (bars 26 – 33 and 65 – 72), an eight-bar phrase is divided into rhythmic units of "3+3+2", further enhancing

the unexpected irregularity and intensity resulting from the omission of musical phrases. Several other factors contribute to the distinctive character of this piece. The use of continuously diminishing seventh chords at the outset, a practice uncommon before 1790, underscores Mozart's innovative approach. Additionally, the proliferation of rhythmic motifs and their developmental forms lends the piece strong coherence and tension. Lastly, the tonal deviation towards the major sixth (E-minor, bars 47 − 56) on the modal scale introduces maximum tonal contrast within such a compact composition. While Symphony K. 16 may not encapsulate Mozart's early talents as comprehensively as this piece, it nonetheless marks a departure from Baroque conventions evident in his evolving compositional style. His two sets of Dutch Theme Variations (K.24 and K.25), penned around March 7, 1766, during his time in the Netherlands, are notable for their relatively moderate demands on performers compared to contemporary accompanying sonatas. However, they exhibit intriguing features. Mozart employs flexible variation as the conclusion of each group, a technique frequently employed in his later variations. Furthermore, both sets of variations maintain a consistent meter throughout, a practice Mozart largely eschewed in his subsequent compositions.

His two sonatas, K.19d (1765) and K.123a (1772), composed for piano duets, offer even greater intrigue. Christian Bach and Wolfgang famously performed improvised duets, with Leopold once proudly declaring that Mozart composed his first four-handed piano piece in London, adding, "No one had ever written a piece for four hands before." In the opening of K.19d, there is a collaborative interplay between an adult and a child, with one player leading while the other imitates. However, this soon transitions into a more balanced interaction between main melody and accompaniment. In the latter sonata, Mozart himself established the defining characteristics of this

chamber music genre.

His initial published works comprised two plucked harpsichord sonatas with optional violin accompaniment (K.6 and K.7), compiled from earlier compositions in 1764 and dedicated to Princess Victoire of France. Originally conceived for solo keyboard instruments, violin parts were made available to cater to the prevailing Parisian musical tastes of the era. Among these "armpit style" sonatas, K. 6 features four movements: "Allegro/Andante/Minuet and Trio/Allegro", while K.7 adopts the Viennese format of "Allegro/Andante/Minuet and Trio". The slow movement of K.7 serves as an early example of the "dreamlike Andante" mentioned later. Within the texture of this movement, there is a continuous stream of triplet figures, with bass accompaniment below and a diaphonic melody above.

Two sonatas (K.8 and K.9) closely followed, both dedicated to Countess Tess. In this second piece, a discernible stylistic progression emerges compared to the preceding sonata. This evolution is evident not only in the adept use of "false recapitulation" in the structure of its 276-bar first movement or the intricate and flowing bass lines, but also in the notable variability of its texture.

These two collections, published in Paris, were printed under the titles Op.1 and Op.2. Subsequently, Op.3 was released, comprising six sonatas with violin and cello accompaniment, published in London and dedicated to Queen Charlotte. The influence of Christian Bach on Mozart is palpable, particularly in the structure of two movements across three capitals. The accompanying violin part typically fills in at the end of phrases, acting as a bridge that connects the various melodic elements of the keyboard part. Meanwhile, the cello part serves the function of playing the bass, occasionally repeating the keyboard's bass line or simplifying it.

Mozart's first seven string quartets were composed in Italy before

the family's return to Salzburg in 1773. The first, K.80, stands out as the most atypical, having been written in Lodi in 1770. It is believed to exhibit the influence of Giovanni Battista Sammartini. Originally composed in three movements (with a fourth movement later added), this work's writing style markedly differs from Mozart's later conceptions of string quartets. In the first two movements, the cello and viola function primarily as bass instruments, while the majority of the melodic material is allocated to the violin parts, resembling a trio sonata and akin in scoring to most contemporary symphonies.

The subsequent six quartets, K.155 – 160, were likely composed in Italy towards the end of 1772 and early 1773. While none of the manuscripts are dated, they appear to have been conceived as a cohesive set of five-degree cycles, with tonal arrangements organized in the sequence of D, G, C, F, ♭B, and ♭E.

By 1772, Mozart had discarded all unsatisfactory aspects of his early works. The construction of melody adheres to the principles of coherence and self-sufficiency; short phrases balance each other in a successive relationship, structured not only by beats and rhythms, but also through the upward and downward movements of the melody, reminiscent of reflections and resolutions.

During his visit to Vienna, Mozart presented his operetta *Bastien und Bastienne* at the home of their affluent friend Dr. Mesmer. This marks Mozart's earliest play to retain its theatrical influence fully, based on Rousseau's successful work *Le devin du village* (1752). As a quintessential singspiel, it features soliloquies and brief, melodious complete vocal pieces, the latter referred to as "arias" or "aria" in singular, also known as set pieces. Before and after his European tour, Mozart amassed considerable experience in composing operatic arias for various voices. He had grown accustomed to conveying diverse dramatic emotions and freely crafting tender or impassioned melodies.

Additionally, he composed *Apollo et Hyacinthus*, an interlude, based on comical Latin texts. The opera comprises a single-movement short overture followed by recitatives and arias, some of which are lyrical and charming. Part 7 features an aria written for a grieving father whose son has just been killed. The lyrics depict him as a solitary boat tossed on a stormy sea. Both the vocal part and the accompanying band evoke the emotional depth of young Mozart's content by painting a musical picture: the intensity of each bar fluctuates; the melodic line continually ascends and descends. All elements of the opera collaborate to depict a soul in profound anguish and a sailing vessel buffeted by wind and waves. The handling of the band is exemplary, showcasing Mozart's ability to transcend convention and craft textures conducive to dramatic expression. The extended and melodious duet melody (Part 8) is performed by the first violin, accompanied by pizzicato strings on strong and weak beats for the double bass and first violin, respectively. Meanwhile, the "divided" viola plays sixteenth notes, indicating an orchestral technique reminiscent of *Women's Hearts*. Compared to later works composed for Italy and Vienna during this period, *Apollo* exhibits a more sophisticated technique and a richer musical imagination. Mozart's comic opera *Bastien und Bastienne* demonstrates Mozart's mastery of short, melodious arias, capable of crafting intricate variations and necessary embellishments atop simple, song-like structures, akin to his compositions of Italian arias. Mozart's first formally popular opera was a commissioned work from Milan in 1770, titled *Mitridate, Re di Ponto* (K.87). The libretto, adapted from Racine's original work by Vittorio Amedeo Cigna-Santi, is considered "the best formal opera platform Mozart ever had". Mozart's final opera for Italy, *Lucio Silla* was a formal opera penned by Giovanni de Gamerra (1743—1803). Gamerra adopts a Metastasio-style tone that is conducive to touching hearts and moral exhortation, weaving a narrative where loyalty in love

leads to disloyalty and betrayal of friends. In the end, dictator Lucio Silla opts for forgiveness rather than executing the guilty, symbolizing inclusivity. The six characters in the opera are divided into two categories: four sopranos and two tenors. While conforming to convention, Mozart showcases his rapidly evolving personal style through this work. In *Lucio Silla*, the band assumes a more prominent role, its utility surpassing that seen in *Mitridate* and *Ascanio in Alba*. The lush texture serves not merely as accompaniment but as an organic component of the overall chamber music style. Though the return aria with abundant embellishments remains prominent, the arrangement of aria types is more varied. Clear signs of the composer's future development can be discerned in melody and harmony. In the opera's closing aria, the male protagonist sings at a minuet's pace. The smooth, sweet melody, accompanied by robust instrumental support, creates an unforgettable, poignant effect akin to Mozart's most mature works. Notably, the harmonic vocabulary employed to convey complex emotions is striking. Critics unanimously agree that Mozart seamlessly blends comedy and tragedy, humor and sorrow into an unparalleled realm, with his late operas *Don Giovanni* and *Women's Hearts* standing as pinnacles of the genre. In *Lucio Silla*, Mozart handles two similar theatrical scenes differently. In the first scene, heroine Giunia rejects the advances of tyrant Lucio Silla, convinced he murdered her husband. Giunia's aria begins slowly and contemplatively, expressing her love for her late husband before swiftly rejecting the suitor. This alternation between reminiscence and reality follows an ABAB structure, concluding with a definitive ending. Such an aria, featuring a vast emotional range, was groundbreaking for its time. In the second scene, Cecilio, believed to be deceased and plotting Silla's demise, sings an aria that is not a mere recapitulation. He depicts his mixed emotions of hope and anger. While the primary key of the aria is D major, shifts to

the subdominant range frequently occur, oscillating between G major and G minor. Coupled with robust rhythmic support and orchestration featuring trumpet and timpani, it presages the moment when Don Giovanni faces his fate at the gates of hell.

Mozart's creative style exhibits remarkable boldness, resonating globally. His religious vocal compositions not only challenged traditional perceptions of sacred songs but also daringly innovated by integrating techniques from instrumental works. This approach endowed his religious music with a grand, powerful, and operatic style, evoking widespread and intense emotional responses. Such direct emotional expression sets him apart from other sacred music composers. For instance, Johann Sebastian Bach, a master of religious music, adopted a cautious and conservative approach, meticulously conveying his reverence and awe of God. Bach's religious compositions reflect the profound sense of separation between humanity and the divine. Later generations described Bach's religious music as "closest to the voice of God," given its unquestionable authority. In contrast, Mozart's demeanor resembles that of a playful child, infusing his music with a tender portrayal of God's love. Mozart's style diverges from that of most composers; his compositions seldom convey emotions of pain, confusion, or contradiction. Despite facing illness and financial struggles in his later years, Mozart remained steadfast in his artistic pursuit. His compositions epitomize "pure musicality," embodying the essence of authentic, exquisite, and beautiful music with purity and spirituality. His music, akin to pearls, exudes warmth and radiance, brimming with youthful vitality. Even in the most intricate musical forms, Mozart's compositions retain a sense of clarity and transparency. Melancholy and darkness are scarce in his music, and if present, they fleetingly pass by, as Mozart silently endures personal hardships, finding solace in his unwavering beliefs and offering comfort to others

through warm and uplifting melodies. Reflecting on his life, Mozart once remarked, "My heart is serene. I do not feel weary. Destiny has determined my path; I embrace it with an open mind and fearless spirit. Life was once beautiful, and in moments of utmost joy, I embarked on my life's journey. Even now, fate continues to favor me."

### 2.3.4 Mozart's Music Creation Characteristics and Their Influence on the Development of Music in Later Times

Mozart's creative techniques not only reflect the style and aesthetics of classical music but also exert a profound impact and provide inspiration to later musicians and the development of music. Mozart's creative techniques are closely intertwined with his personal experiences, personality, emotions, and other factors.

Mozart exhibited extraordinary musical talent from childhood. Under his father's guidance, he mastered various instruments and composition techniques. Influenced by masters like Bach and Haydn, his early works reflected both his exploration of different music styles and forms and his innovative spirit. Embarking on a lengthy European tour in his youth, Mozart encountered numerous musicians and aristocrats across different countries and cities, broadening his musical vision and knowledge. His compositions also mirrored his keen observation and absorption of diverse cultures and customs. In adulthood, seeking freedom and independence, Mozart broke away from the confines of the Salzburg court and settled in Vienna, becoming one of history's earliest freelance composers. During his time in Vienna, he crafted numerous remarkable operas, symphonies, concertos, sonatas, and other works, showcasing his mastery and advancement of the classical music style. Mozart's personality was multifaceted and complex, blending childlike innocence and humor with mature and profound thoughts and emotions. His music, too, reflected this

diversity, ranging from relaxed and cheerful to tragic and poignant, from sarcastic to solemn and reverent. His emotional life deeply influenced his compositions, as he navigated complex relationships with family, friends, and others, expressing his understanding and experiences of emotions such as familial bonds, friendship, and love through his music.

Mozart's creative techniques encompass superb mastery of melody, harmony, structure, orchestration, and other elements. He adeptly applies these musical components across various genres and situations, crafting works that are beautiful, fluid, and deeply expressive. His music exhibits both melodic lyricism and dramatic contrast, adhering to the norms and balance of classicism while also showcasing his individuality and innovation. Reflecting his personal experiences, personality, and emotions, Mozart's creative techniques imbue his works with distinctive characteristics of his time and societal significance. In his operas, he unveils the corruption and ignorance of the aristocracy while celebrating the wisdom and bravery of the common people, embodying ideals of democracy and equality. In *The Magic Flute*, he integrates diverse musical styles and cultural elements, metaphorically representing Freemason ideals and the universal human pursuit of truth, beauty, and freedom. Mozart's creative legacy extends beyond his era, profoundly influencing future musicians and musical development. His timeless works across various genres such as operas, symphonies, concertos, and chamber music serve as rich resources and exemplars for subsequent generations. Additionally, his innovations in musical form, structure, and orchestration laid the groundwork for Romantic composers like Beethoven. Furthermore, Mozart's music holds enduring value for contemporary music education and appreciation, fostering aesthetic sensibility and emotional intelligence in listeners.

The singing techniques employed in Mozart's vocal works are both

straightforward and magnificent. While they possess grandeur, they are not intended for mere sensationalism. One often encounters essential syllables extended infinitely through rapidly flowing notes, enriching both the expression of musical content and the singer's enjoyment. His vocal compositions have elevated the artistic caliber and stature of opera. Within this genre, he explored various styles and forms, including comic opera, serious opera, mythological opera, and historical opera, among others. Mozart's operatic oeuvre is considered exemplary of the Classical period and has exerted a profound influence on subsequent Romantic and Modernist operatic traditions. The characterization and emotional depth depicted in Mozart's operas are of exceptional quality. His music adeptly captures the personalities and psychological states of characters while also conveying diverse social and political viewpoints. Mozart's vocal compositions showcase his mastery of embellishments, variations, progressions, and counterpoint, rendering his melodies both aesthetically pleasing and emotionally resonant. Moreover, Mozart skillfully integrates vocal and instrumental elements in his compositions, assigning instrumental parts significant roles and functions within vocal pieces. Instrumental music not only accompanies and enhances vocal performances but also independently expresses musical content and emotion. Mozart creates intricate relationships and dialogues between vocal and instrumental components, employing techniques such as contrast, counterpoint, imitation, and response to create an organic unity between the two. One notable example of Mozart's prowess in religious vocal composition is *Exsultate Jubilate* ( K. 165 ), a remarkable work that exemplifies his level of skill and stylistic finesse. This composition has had a profound impact and continues to inspire future vocalists and singers with its beauty and depth.

Mozart's music features rich and diverse melodies, showcasing his adeptness in employing embellishments, variations, progressions, and

counterpoint to craft melodies that are both beautiful and smooth, as well as expressive and imaginative. His musical structures are characterized by clarity and flexibility. While he mastered various classical forms such as sonata form, rondo form, and variation form, Mozart also demonstrated creativity by innovating within these structures to suit the needs of musical content and emotional development. Furthermore, Mozart's compositions exhibit rich and intricate harmonies, employing diverse harmonic colors and tonal techniques that lend charm and depth to his music. He notably pioneered the use of wind instruments like the clarinet and bassoon in symphonic compositions. Mozart's repertoire encompasses a wide range of styles and atmospheres, including lighthearted, cheerful, tragic, touching, satirical, and solemn compositions, tailored to different occasions and purposes. His operatic works, in particular, excel in portraying and expressing character and emotion.

Mozart's creative techniques not only epitomize the style and aesthetics of classical music but also reflect his individual artistry. His compositions bear the imprint of his personal experiences, personality, emotions, and other factors, thereby expressing his distinctive style and innovative spirit.

Mozart employed a rich array of musical language and techniques in his operas, effectively bringing characters and plots to life. He demonstrated the ability to adapt music styles and atmospheres to suit different characters and scenes, thereby infusing the opera with drama and contrast. For instance, in The *Marriage of Figaro*, he employed various musical genres including arias, duets, trios, quartets, and choruses. These segments were interspersed with recitative passages, sung in a rhythm and intonation akin to everyday speech, accompanied solely by the harpsichord. Each opera comprises a series of distinct musical events, with each segment clearly demarcated by a defined

beginning and end. This division is so evident that, in a well-executed performance, the audience often responds with warm applause at the conclusion of each segment. These fundamental musical units share several similarities. Typically, each segment lasts approximately three minutes and maintains a consistent tonality, rhythm, tempo, and accompaniment style. They may feature either a single tone or, if varied, two contrasting passages—one slow and the other fast. Repetition of melodic material is also a characteristic trait. Moreover, Mozart employed various musical techniques such as imitation, counterpoint, variation, and fugue to express the personalities of different characters and depict emotional changes. He skillfully utilized melodic conventions and harmonic traditions, ensuring stable and coherent phrase structures alongside transparent and well-organized harmonic progressions.

Mozart showcased his ability to convey both singing and lyricism through his piano compositions, while also demonstrating mastery of piano timbre and technique. He adeptly expressed profound and delicate emotions using simple yet beautiful melodies, alongside showcasing superb and sensitive skills through complex and exquisite structures. For instance, in *Fantasia and Sonata in C minor*, he employed various musical forms such as Fantasia, Sonata, and Fugue, along with musical elements like chromatic scales, decorative notes, and counterpoint, to evoke a tragic and passionate atmosphere.

In chamber music, Mozart displayed a keen focus on achieving balance and coordination among vocal and instrumental parts, while also exploring the characteristics and possibilities of different instruments. He crafted independent and expressive melodies for each voice part and ensured close and harmonious coordination among them. Additionally, he adeptly created diverse musical effects and styles based on various instrument combinations. For instance, in the Clarinet Quintet in B-flat major, he skillfully utilized the singing quality and

flexibility of the clarinet, fostering a beautiful and melodious dialogue with the string instruments.

Throughout his career, Mozart composed a substantial number of religious works, including prayers, evening prayers, hymns, oratorios, cantatas, religious plays, church sonatas, masses, and religious short songs. These religious genres constituted a significant portion of Mozart's extensive oeuvre, which comprised over 600 works during his lifetime.

As Western composers, creating works centered around religious music is a natural endeavor, as religion holds profound significance in their lives. Composers are intimately acquainted with the patterns and structures of religious music, which often serves as the genesis of their creative endeavors.

Some argue that Western music is intricately intertwined with religious beliefs. The development and evolution of both vocal and instrumental music can be viewed not merely as a transformation of artistic techniques, but rather as a reflection of the profound yearnings of the human soul. In the realm of vocal works, religious music sometimes poses challenges, feeling awkward and difficult to comprehend and perform. However, this work, which was composed when Mozart was merely 17 ears old, possessed a beautiful and deeply moving musical essence comparable to opera arias, rendering it among the most renowned early religious compositions. Mozart's oeuvre includes such pieces, some composed when he was merely 17 years old.

Mozart was a devout believer, a sentiment expressed in his letters. When *Exsultate Jubilate* was first performed, it was sung by a castrati. In modern vocal music, both soprano and falsetto tenor are suitable for performing it. Some compare it with Handel's *Messiah* and *Bach's Hail to God*. Undoubtedly, these are great works. However, Mozart's

composition carries a relatively lighter tone with a warm atmosphere. It seems to capture an individual's emotional turbulence, contrasting with the collective religious fervor depicted in *Messiah*. This vocal piece was penned by Mozart in 1773 for a castrati. During this period, Mozart's mental state was quite troubled. His adult life was marked by significant challenges, including transitional fatigue and indulgence, which took a toll on his health. Through this composition, besides experiencing the angelic beauty of Mozart's music, one may also discern a tinge of sadness. While it evokes warmth and emotion, it also invites contemplation of Mozart's circumstances at the time. Despite being a religious scripture song, it undoubtedly reflects Mozart's authentic expression. Like his other vocal compositions, it remains a cherished repertoire for many vocal artists. The most frequently performed segment is the *Allelujah* in the fourth part. Though a praise to God, its melody is upbeat, eschewing the slow solemnity often associated with religious songs, and instead concluding with a warm and cheerful tone.

/ Chapter III /

# Singing Experience of *Exsultate Jubilate*

## 3.1 The Past of Female Singers

In 16th century Europe, due to the prohibition of women participating in public music performances, the soprano voice was often replaced by a boy's voice. Undoubtedly, the tone of a child's voice exudes clarity and purity. However, it also exposes certain limitations. The restricted vocal range of children can somewhat constrain composers in their compositions. Additionally, there is a certain immaturity in terms of expressive power. Moreover, the period during which children's voices can be utilized is relatively short, and with the onset of puberty and the changing of the male voice, there is a significant inefficiency in their training and usage. Although there were instances of men singing soprano using falsetto during this time, the overall sound effect was less than ideal. With the burgeoning popularity of opera, resolving the issue of soprano voices became paramount. It was during this period that a group of singers known as castrato emerged. Mozart's work K.165 was created for the castrati Venanzio Rauzzini. The castrato were first utilized by the Vatican Church. By 1870, Italy declared castration illegal, and in 1902, the Church officially announced the permanent prohibition of castrato from

performing in churches. In 1922, with the death of the last castrati, the nearly 300-year era of castrato finally came to an end.

In the 16th century, female performers with instruments began to appear in oil paintings. They learned to play instruments and sing at home rather than at school. Before the 16th century, apart from a few famous female musicians, women were rarely seen in musical life. With the influence of composers and teachers such as Casulana (active from 1566 to 1583) and the "Concerto diDonne" (female performers' group at the Ferrara court), this situation began to change from the mid-16th century. Even talented individuals like Mozart's own sister, Nannerl, who debuted at the age of 18, bid farewell to her music career amidst societal prejudices. Until the 19th century, women were still not allowed to enter music schools. Therefore, for a considerable period of time, the vast majority of women had little opportunity to receive complete and systematic music education.

## 3.2 Latin in *Exsultate Jubilate*

In Milan in 1773, the composer spent three weeks working on the composition. The piece is primarily divided into four sections, comprising three movements and a recitative, all sung in Latin. Despite its classification as a vocal suite, it exudes a strong sense of aria performance. When considering the lyrics, attention must be paid to the pronunciation of the Latin language. Proper emphasis should be placed on vowel length and voiced consonants, adhering to contemporary linguistic norms. Furthermore, the interconnection of individual phonemes should align with established language conventions. It is widely acknowledged that the interplay between singing and language is paramount. Rhyme, in particular, serves as an exaggerated manifestation of linguistic artistry. Only through a profound comprehension of

language pronunciation can one effectively convey its nuances.

Latin belongs to the Indo-European language family, specifically the Italic branch, and originated as a local dialect in the Lazio region of Italy. It later became the official language of the Roman Empire and exerted significant influence on the development of European languages. Presently, Latin finds application in ceremonial contexts, ancient poetry and literature, as well as specialized fields such as medicine, chemistry, and botany. The Latin alphabet, which emerged around the 7th century BC, was initially derived from early Greek letters and subsequently adapted from Etruscan script, reducing the original 26 Etruscan letters to 21. The original Latin alphabet included: A, B, C (representing /g/ and /k/), D, E, F, Z (Zeta in Greek), H, I (representing both I and J), K, L, M, N, O, P, Q, R (though written as P for a considerable period), S, T, V (representing U, V, and W), X. Following the conquest of Greece in the 1st century BC, the Latin alphabet incorporated the Greek letters Y and Z, which were positioned at the end of the alphabet. This modification resulted in a Latin alphabet comprising twenty-three letters. Notably, it wasn't until the Middle Ages that the letter J (distinguished from I) and the letters U and W (distinguished from V) were added.

The pronunciation of Latin reflects the modern interpretation of written Latin texts by contemporary speakers. Within monosyllabic words, there is no concept of light stress. Stress in polysyllabic words typically falls on the penultimate or third syllable and correlates with syllable length, which in turn is determined by vowel length and syllable composition. Syllables containing long vowels are inherently long, as are closed syllables regardless of vowel length. In words of three or more syllables, the penultimate syllable is stressed if it is long, while stress shifts to the penultimate syllable if it is short.

In the discussed work, particular attention should be given to

pronouncing the final "e" in the phrase "o vos animae beatae" ensuring it is not elided. Clarity of pronunciation is paramount. Similarly, in the phrase "vestro respondendo," attention should be paid to the sound of the "o." Another example is the word "a" in "Tu virginum corona" and "tu nobis pacem dona." In general, each vowel should be articulated distinctly and smoothly. When unable to sing a vowel, it should be swallowed. Rhyme in words must be clear, avoiding ambiguity, and naturally leading to the end rhyme.

In addition to tone, it's crucial to grasp the meaning of each word and phrase combination in the work. Singing vocal music entails more than mere imitation; to convey emotions effectively, one must understand the intention behind each sound produced. This intentionality extends beyond merely approaching overarching emotions; to express emotions with precision, one must comprehend the specific meaning of the lyrics and their relationship to the phrases.

## 3.3　Singing Tips of *Exsultate Jubilate*

In this piece, the predominant emotion is one of praise. Mozart intended it to be both lyrical and joyful. In the opening movement, Mozart employs a cheerful tone and emphasizes voice control accompanied by colorful accents. Lyrical passages require adjustment of timbre effects, avoiding extremes of loudness or dullness. The flexibility of the vocal cavity should be maintained, enabling agile sound production while ensuring accuracy. When performing this florid melody, it's essential to maintain a stable mindset and avoid treating it as a grand aria from an opera. To capture the appropriate lyrical singing sensation for the music, one must avoid the mindset of showcasing technical prowess.

From a historical perspective, Mozart was in a period of transition

during the composition of this piece. On one hand, the influence of Salzburg's traditions, now being altered by Colloredo, is evident in the simplicity of structure present in works such as K.165, K.192, and K.194. These compositions feature minimal word repetition, straightforward choral recitation, and musical treatment reflecting the text's meaning. However, Mozart's creative output was not confined solely to this style. On the other hand, his compositions were also influenced by the Italian style, incorporating elements of secular music and presenting a magnificent aria style in his works. During this period, Europe was undergoing the Enlightenment movement, advocating for free and uncomplicated musical forms, breaking away from the constraints of courtly or overly ritualistic music. This societal shift is vividly reflected in Mozart's music as he began to focus more on his inner world, departing from compositions designed solely to please the aristocracy and nobility.

From the vocal works of that time, the main presentation was simple and fluid music, characterized by a relatively calm and elegant overall counterpoint, devoid of significant emotional fluctuations, and emphasizing praise and longing for beauty. Therefore, composers placed great importance on the emotional stability of music in their compositions, reflecting the overall aesthetic style of the period. In the creation of K.165, Mozart employed many operatic writing techniques. The music as a whole incorporates the creative concept of concertos. While maintaining overall stability, appropriate embellishments are necessary to prevent excessive dullness in the music. In the fast-paced sections of a composition, it is crucial to control the sound and coordinate breath control with pitch, speed, and intensity when executing the sixteenth note passages. Similar to the performance of musical instruments, in the initial stages, singers must undergo breathing training to avoid the habit of gasping for air during rapid

passages. Smooth and steady breathing is essential for performing the entire piece well, whether it be the long phrases at the beginning or the rapid florid passages. All demand a solid vocal foundation.

In terms of breath control, one should avoid raising the shoulders due to the relationship between speed and pitch. Instead, it's important to find a downward support point, engage the muscles of the diaphragm to regulate breathing, and use breath to engage the vocal cords for sound production, rather than straining the vocal cords to produce high notes or ornamental effects. Correct positioning of the throat is also essential, avoiding excessive downward pressure or abrupt changes, to maintain stability. This allows for close coordination between vocal fold movement and breathing, adjusting application function, and preserving timbre consistency across different registers — whether singing high, medium, or low notes. Particularly when interpreting music with varying dynamics, it's crucial to consider one's own abilities and training level, adjusting volume appropriately to achieve optimal sound effects. Additionally, leveraging resonant cavities is vital for vocal resonance and projection.

In terms of intonation, the accuracy of second intervals is paramount. At the outset of the first movement, the instrumental part and the human voice complement each other. If this harmony is disrupted by vocal inaccuracies, it will detract from the overall atmosphere intended by the composer. Therefore, during practice, it's essential to match the singing pace with that of the piano and engage in model singing. Once pitch accuracy is assured, gradually increase the tempo during training. This approach becomes even more critical when facing major leaps, such as the tenth interval within a movement. After addressing intonation, it's vital to practice coordinating phrases with pitch and ensuring proper breath control without disrupting the continuity of phrases. The proper division of breath is key to

successfully executing music, and there are considerable individual variations in this aspect during practical application. Singers should integrate the development of melody and lyrics, adapting their singing techniques and habits for personalized treatment. Additionally, for long phrases, preparatory breathing is essential to execute them more seamlessly.

The recitative after the end of the first movement is a moment for the singer to rest. However, the tone and pitch still need to be precise, especially for the line "Undique obscura regnabat nox," meaning "The darkness that once enveloped the world," which should contrast with the first line of the recitative, "Fulget amica dies," meaning "The beautiful day shines." An analysis of the lyrics reveals that the entire recitative is imbued with a sense of beauty, except for the word "darkness," which should be delivered with a "recitative" feel during the performance.

As for recitative, it originated in the 16th century and evolved into recitative music by the 17th century. Before 1650, opera's most intense moments of passion were often conveyed through recitations, typically in the form of lengthy monologues. This form was further developed in the 18th century by German composer Handel, who integrated German traditions, thus enhancing its expressiveness and diversity. Later, Krieger introduced it into the cantata genre and infused elements of Italian opera, capturing the attention of composers like Bach, who began to emulate its style. Despite its German origins, recitative primarily adopted the linguistic conventions of Italian opera and found widespread use in secular music.

Anyhon, Mozart, with his exceptional musical talent, illuminated the era with his brilliant compositions, leaving behind a rich legacy for future generations. In modern and contemporary interpretations, a more comprehensive artistic interpretation can only be achieved through a

deep understanding of the significant artistic connotations bestowed upon the work by its composers. This understanding of connotation arises partly from analyzing the musical essence of the work, comprehending its creative intentions and principles, and partly from considering the social background and experiences of artists during that period. By effectively blending these elements with one's own vocal abilities, a more ideal artistic expression can be realized.

# 参考文献

**著作**
1. 黑尔德谢默著,《莫扎特论》,华东师范大学出版社,2011年。
2. 卡尔·巴特著,《论莫扎特》,朱雁冰译,华东师范大学出版社,2006年。
3. 沈旋、谷文娴、陶辛著,《西方音乐史简编》,上海音乐出版社,2015年。
4. 沈旋、梁晴、王丹丹著,《西方音乐史导学》,上海音乐学院出版社,2006年。
5. 斯坦利·萨迪主编,《新格罗夫音乐与音乐家辞典》第2版,湖南文艺出版社,2012年。
6. 于润洋主编,《西方音乐通史》,上海音乐出版社,2001年。

**论文**
1. 曹丽,莫扎特宗教声乐套曲演唱技巧分析——以《你们欢呼雀跃吧》中第四乐章为例,中国民族博览,2021(17)。
2. 曹艺,关于莫扎特经文歌《你们欢呼雀跃吧》K.165的分析研究,西安音乐学院硕士论文,2012年。
3. 程博文,谈莫扎特声乐套曲《让我们欢呼雀跃》研究及演唱分析——以《阿里路亚》为例,天津音乐学院硕士论文,2018年。
4. 崔英姿,莫扎特声乐套曲《你们欢呼雀跃吧》——"启蒙运动"思潮影响下的"人性"与"自由",大众文艺,2020(01)。
5. 董钟月,莫扎特的经文歌《你们欢呼雀跃吧》(K.165)的演唱艺术

……研究,陕西师范大学硕士论文,2015 年。
6. 段琦薇,对莫扎特宗教声乐作品的探索与研究——以《你们欢呼雀跃吧》(K.165)为例,山西大学硕士论文,2013 年。
7. 宫珍珍,探究莫扎特宗教声乐套曲《你们欢呼雀跃吧》(K.165),天津音乐学院硕士论文,2019 年。
8. 李佼佼,莫扎特女高音声乐套曲《你们欢呼雀跃吧》K.165 的宗教音乐特点与演唱处理,武汉音乐学院硕士论文,2019 年。
9. 雒恩慈,莫扎特经文歌《喜悦欢腾》的艺术探究,陕西师范大学硕士论文,2018 年。
10. 饶旭琦,莫扎特声乐套曲《你们欢呼雀跃吧》的演唱诠释,云南艺术学院硕士论文,2016 年。
11. 王小乐,莫扎特音乐会咏叹调音乐风格与演唱技巧研究——以两首女高音音乐会咏叹调为例,沈阳师范大学硕士论文,2019 年。
12. 王宇凡,17、18 世纪贝尔康多演唱风格研究——以莫扎特声乐作品 K.165 为例,福建师范大学硕士论文,2015 年。
13. 谢双,莫扎特音乐会咏叹调《你们欢呼雀跃吧》K.165 的演唱分析,山东师范大学硕士论文,2018 年。
14. 杨迦熙,莫扎特套曲《我们欢呼雀跃吧》演唱技巧研究,延边大学硕士论文,2022 年。
15. 于紫涵、匡传英,莫扎特声乐套曲分析——以《哈利路亚》为例,当代音乐,2022(5)。
16. 袁陈平,莫扎特宗教声乐作品的演唱探究——以经文歌套曲《喜悦欢腾》为例,云南大学硕士论文,2022 年。
17. 张静雅,莫扎特宗教圣乐套曲《喜悦欢腾》分析与歌唱演绎,北方音乐,2012(2)。
18. 张宇航,莫扎特经文歌套曲《你们欢呼雀跃吧》(K.165)的分析与演唱研究,南京师范大学硕士论文,2018 年。
19. 朱倩玉,莫扎特声乐套曲《你们欢呼雀跃吧》两个音响版本的比较分析,武汉音乐学院硕士论文,2017 年。

# 附 录

## 一、《欢腾喜悦》歌词大意

Exsultate, jubilate,
喜悦欢腾
o vos animae beatae,
哦,有福的灵魂
dulcia cantica canendo,
唱着甜美的歌
cantui vestro resposdendo,
唱着你的歌
psallant aethera cum me.
诸天与我一起歌颂

Fulget amica dies,
美好的日子闪耀光芒
jam fugere et nubila et procellae;
云与风暴已成过往
exortus est justis inexspectata quies.
意料之外的安宁降临义人
Undique obscura regnabat nox,
曾经的笼罩着世界的黑暗
surgite tandem laeti.

终于浮现喜悦
qui timuistis adhuc,
心内一直忧惧的你
et jucundi aurorae fortunatae,
满心欢喜迎接幸福的晨光
frondes dextera plena et lilia date.
献上华丽花环和百合
Tu virginum corona,
你,圣母的花环
tu nobis pacem dona,
赐予我们和平
tu consolare affectus,
消除我们内心的悲伤
unde suspirat cor.
我们打心底叹服

Alleluja
阿利路亚

## 二、《欢腾喜悦》乐谱

### EXSULTATE, JUBILATE

W.A.MOZART
K.V.165

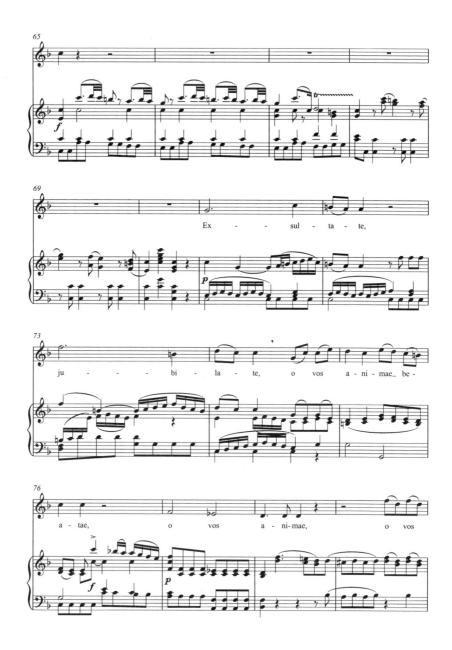

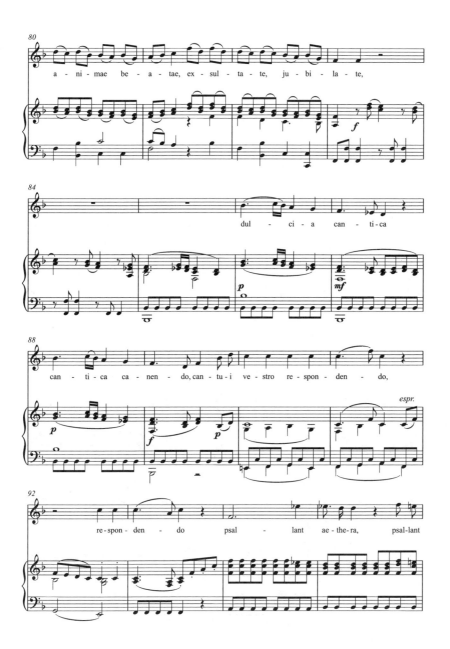

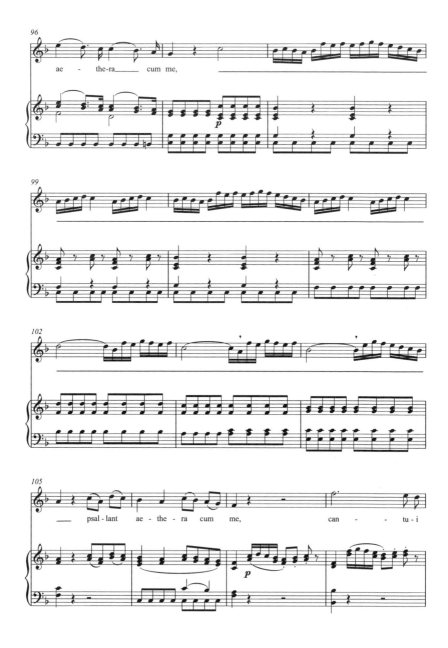

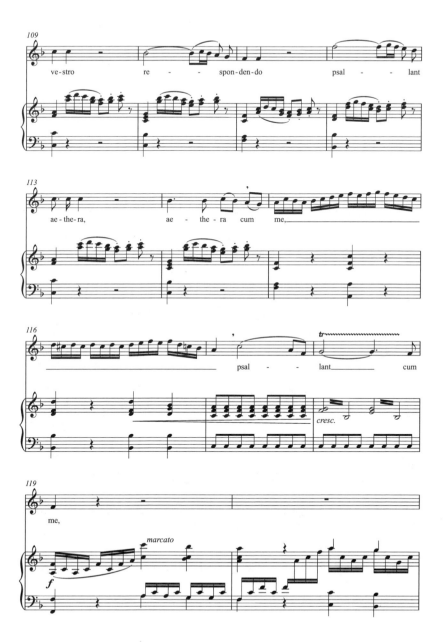

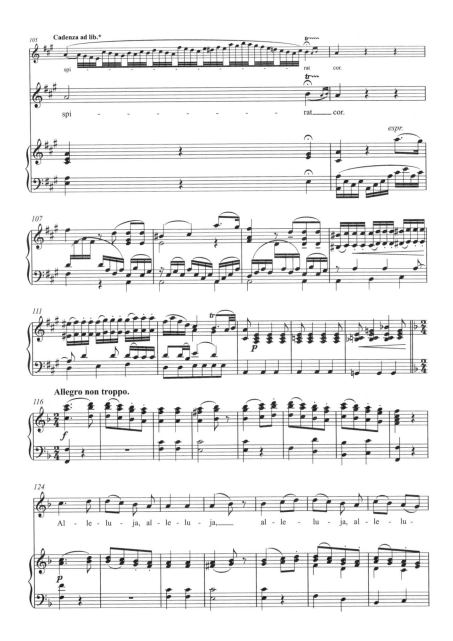

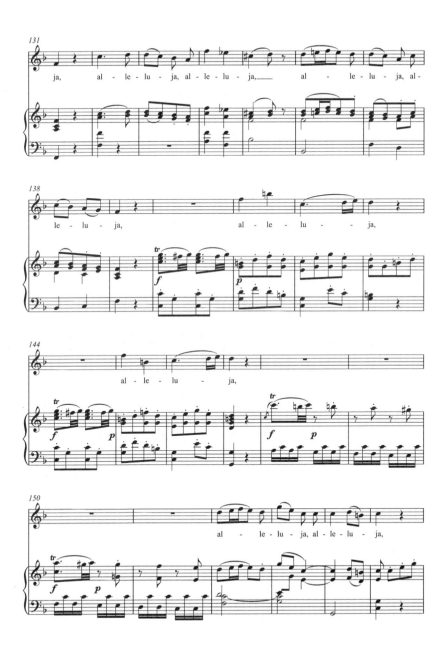

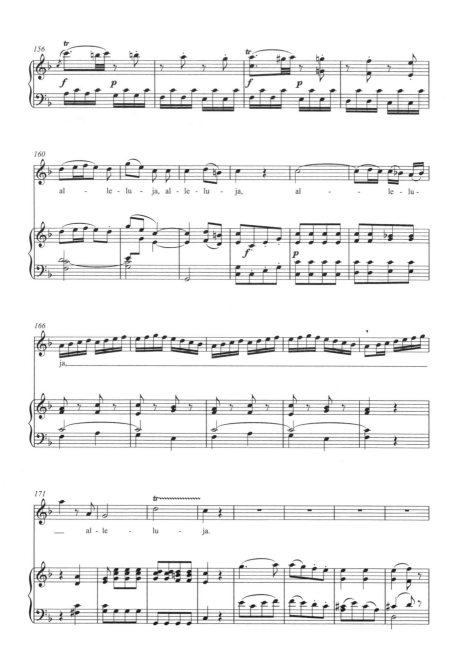

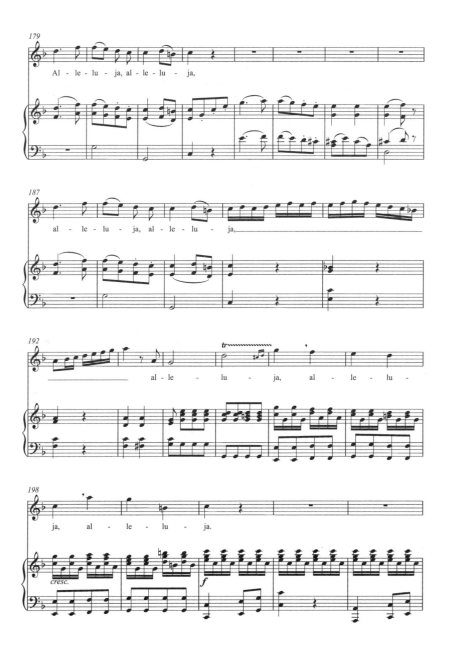

160 莫扎特与《欢腾喜悦》

162　莫扎特与《欢腾喜悦》

# 后 记

完成书稿后,我于 2023 年在上海新天安堂再次演唱了这部《欢腾喜悦》。新天安堂的声音效果接近莫扎特创作这部《欢腾喜悦》的原意,因此我有了新的体验和感悟。本书未分析到之处,望专家读者不吝赐教。

这部作品的录音由我本人演唱完成,自从初次学习这部作品,至今已经过了 15 年,在这期间,我的发声习惯也有所改变,演唱中的处理也有所不同。我要感谢声乐老师李建林教授的指导,以及录音师董唯一老师的辛勤工作。

# Postscript

After completing the manuscript in 2023, I performed the song *Exsultate Jubilate* once again at the New Tian'an Hall in Shanghai. The acoustics of the New Tian'an Hall closely resemble the original ambiance intended by Mozart for *Exsultate Jubilate*, thus providing me new insights. I hope experts and readers give me some advice on what is not analyzed in this book.

The recording of this work was done by me, and it has been 15 years since the initial study of this piece. Over this period, my vocal habits have evolved, resulting in changes in singing technique. I express gratitude to Professor Li Jianlin, the vocal instructor, for his guidance, and Mr. Dong Weiyi, the recording engineer, for his hard work.